THE
PRE-RAPHAELITES

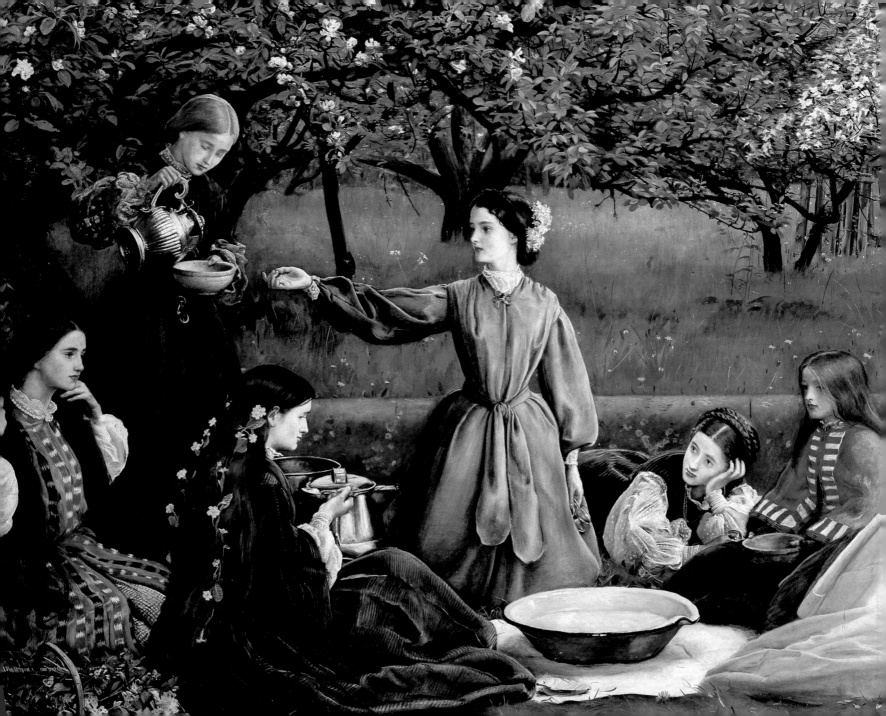

THE PRE⁄RAPHAELITES

*Their Lives in
Letters and Diaries*

Jan Marsh

COLLINS & BROWN

First published in Great Britain in 1996
by Collins & Brown Limited
London House,
Great Eastern Wharf
Parkgate Road,
London SW11 4NQ

FRONT COVER: *Laus Veneris* (1873-8) by
Edward Burne-Jones. Laing Art Gallery,
Newcastle upon Tyne.

HALF-TITLE: Detail from the
frontispiece designed for *Early
Italian Painters* (1861) by Dante
Gabriel Rossetti.

British Library Cataloguing-in-Publication Data:
A catalogue record for this book is available from the British Library.

ISBN 1 85585 246 2 (hardback edition)
ISBN 1 85585 269 1 (paperback edition)

FRONTISPIECE: *Spring* (1859)
by John Everett Millais.

ENDPAPERS: 'Willow bough' wallpaper by
William Morris.

Conceived, edited, and designed by Collins & Brown Limited

Editor: Elizabeth Drury
Picture research: Philippa Lewis
Art Director: Roger Bristow
Senior Art Editor: Ruth Hope
Designer: Bill Mason

Reproduction by Daylight Colour Art, Singapore

Printed in Italy

CONTENTS

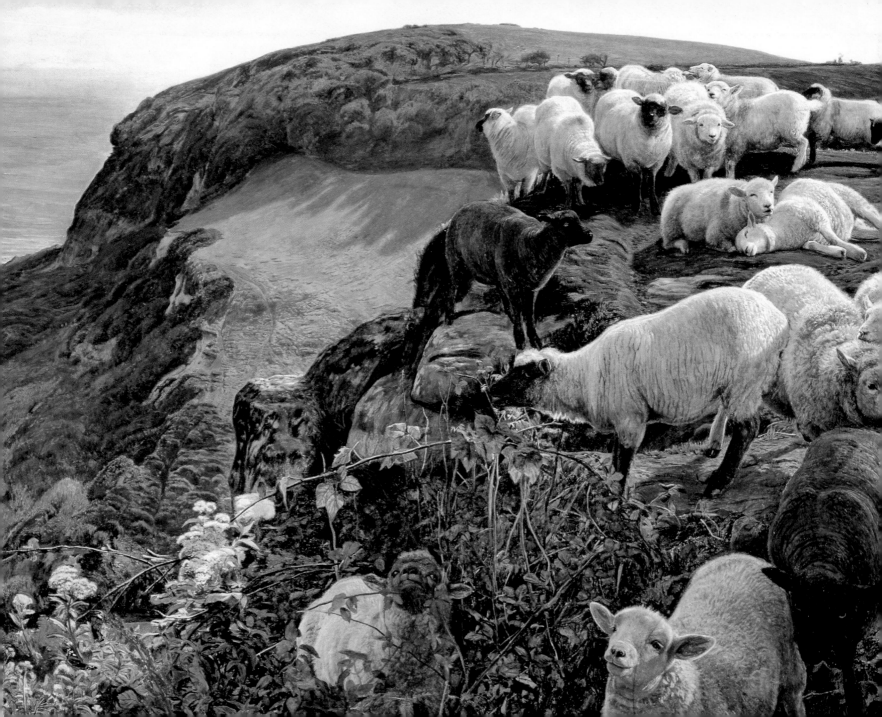

INTRODUCTION

LEFT: Our English Coasts *(1852) by William Holman Hunt, painted on the Sussex cliffs near Fairlight. Ruskin praised the picture for its 'absolutely faithful balances of colour and shade' in sunshine and shadow.*

PRE-RAPHAELITE PAINTINGS are rich in colour and atmosphere, full of dramatic or chivalrous action, or infused with intense, enigmatic emotion. They seem to relate to a long-lost world of beauty and romance; yet the Pre-Raphaelite Brotherhood was one of the first modern movements in British art – a true avant-garde.

> Look around at our exhibitions, and behold the 'cattle pieces', and 'sea pieces', and 'fruit pieces', and 'family pieces'; the eternal brown cows in ditches, and white sails in squalls, and sliced lemons in saucers, and foolish faces in simpers; – and try to feel what we are and what we might have been.

Thus wrote John Ruskin, at the start of his defence of the Pre-Raphaelite Brotherhood, describing the debased state of British painting at the end of the 1840s that resulted from antiquated teaching, lazy adherence to exhausted ideas and imitative practice.

Within a few years the P.R.B., the aims, friendships and artistic achievements of which are revealed in this book through the artists' own letters, diaries and reminiscences, had revitalized British art, with a new look and idealism.

> The Pre-Raphaelites imitate no pictures: they paint from nature only. But they have opposed themselves as a body, to that kind of teaching ... which only began after Raphael's time ... Therefore they have called themselves Pre-Raphaelites. If they adhere to their principles and paint nature as it is around them, with the help of modern science, with the earnestness of the men of the thirteenth and fourteenth centuries, they will ... found a new and noble school.

It is a matter of discussion as to whether the Pre-Raphaelites and their followers did adhere to the original principles and ideals of the movement, or whether they deviated from absolute fidelity to nature in favour of a more romanticized art in the Pre-Raphaelite second generation, whose aim, in the words of Edward Burne-Jones, was to paint images of an imagined world:

> I mean by a picture a beautiful romantic dream of something that never was, never will be – in a light better than any light that ever shone – in a land no one can define, or remember, only desire .

It is probably true to say that Pre-Raphaelitism evolved, in terms of style, from a meticulous, highly-detailed way of painting to a softer, less sharply-focused manner. Glowing, harmonious colour remained a hallmark, however; so too did imaginative subjects, often based on literature and legend – part of the Victorians' exploration of their own world through the lens of the past. As Dante Gabriel Rossetti once said:

> I do not wrap myself up in my imaginings, it is they that envelop me from the outer world, whether I will or no.

It was a new way of seeing that modulated into imaginings and desire – and in the process produced bright images, delicate drawings, vivid and erotic poems; not forgetting many warm, witty letters with comic caricatures, for the P.R.B. and their friends were full of the joys of life and youth, never pompous or self-important. Their voluminous correspondence – acute, affectionate, romantic and ribald by turns – reflects their lives, interwoven with each other into a bright tapestry.

Pioneering in their day, Pre-Raphaelite pictures now evoke a past world of visual brilliance. And the linked lives and loves of the painters and their partners exert a similar fascination. In their relationships we glimpse a charmed circle that began with the 'boys of the Brotherhood'

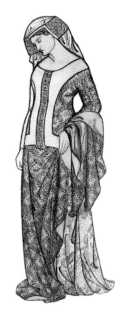

ABOVE: *Medieval lady designed by William Morris and used for both embroidery and stained glass. The dress resembles that on the effigy of Philippa of Hainault in Westminster Abbey, a replica of which was worn by Queen Victoria at a costume ball in 1842.*

8

and their 'Pre-Raphaelite sisters' and continued in the circle around William Morris and Edward Burne-Jones. Eventually the bright spheres dimmed and faded, but at its best this was a world where deep love and friendship intersected with poetry and painting to produce beautiful images that have lost none of their lustre.

LEFT: Sir Galahad at the Ruined Chapel *(1855), a wood-engraving by Dante Gabriel Rossetti to illustrate Tennyson's lines:*
Fair gleams the snowy altar-cloth,
The silver vessels sparkle clean,
The shrill bells rings, the censer swings,
And solemn chaunts resound between.

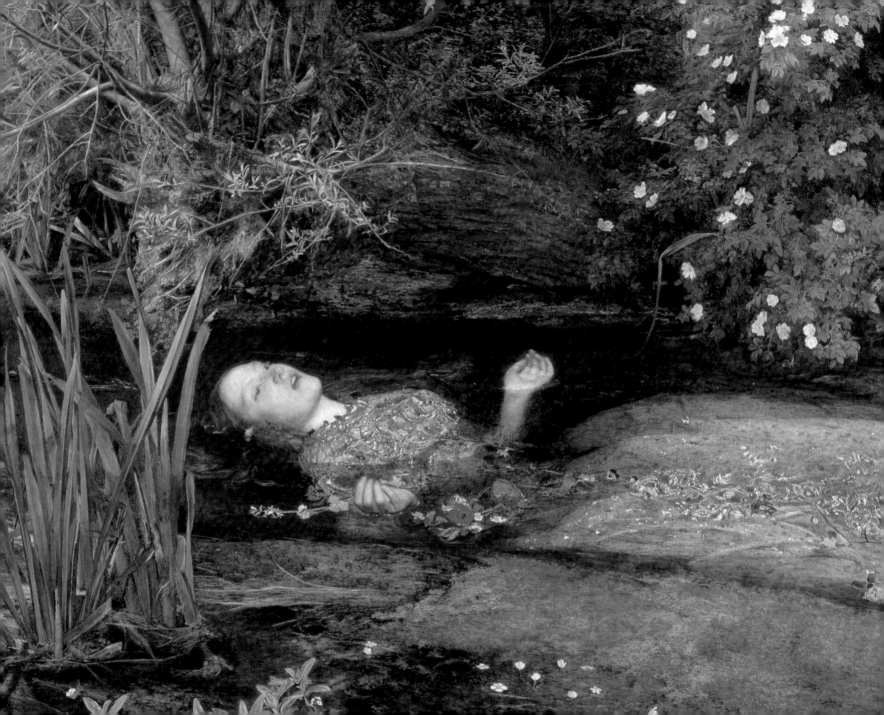

Chapter One

THE P.R.B.

I T WAS SPRING 1848 – the year of revolutions in Europe. In London, two young men, not long out of art school, went to watch the great Chartist demonstration of working men demanding political rights for all citizens. They were inspired by curiosity, and some sympathy, rather than by militancy, and in the event the marchers were easily dispersed: this was the last such demonstration for twenty years. For despite famine in Ireland and urban squalor elsewhere, the mid-Victorian age brought prosperity and confidence for Britain – a time of economic expansion, global exploration, artistic innovation.

The two students were John Everett Millais, then aged nineteen, and William Holman Hunt, aged twenty-one. They were working together in Millais's studio, anxious to complete their pictures for the prestigious Royal Academy exhibition, as Hunt later recalled:

> The date for sending in works came alarmingly near. Millais had
> progressed more bravely than I, but he had yet more to do, and we
> agreed that neither of us could finish without working far into, and
> even all through, the last nights ... On one occasion, becoming
> fatigued, he suddenly, with boyish whim, conceived a prejudice against
> the task of painting some drapery about the figures which still had to
> be done, and entreated me to relieve him. 'Do, like a dear fellow, work
> out these folds for me; you shan't lose time, for I'll do one of the heads
> of your revellers for you'... I can to this day distinguish the part he did
> for me, adapting his handling to my manipulation by precise touch.

Millais was a youthful genius who had exhibited his first painting at the age of sixteen, whereas Hunt had had to make his own way against parental opposition. He was the first to discover *Modern Painters*, the

OPPOSITE: Ophelia *(1852) by John Everett Millais, illustrating the lines beginning 'There is a willow grows aslant a brook' from* Hamlet. *Shakespeare was one of the P.R.B's 'Immortals'.*

polemical book by John Ruskin that urged young artists to 'go to nature in all singleness of heart' and think for themselves, rather than merely copy the dead art of previous generations. Hunt remembered explaining to Millais:

> I have investigated current theories both within art and outside it, and have found many of them absolutely unacceptable. What, you ask, are my scruples? Well, they are nothing less than irreverent, heretical and revolutionary... no young man has the faintest chance of developing his art into a living power, unless he investigates the dogmas of his elders with critical mind and dares to face the idea of revolt from their authority.

Why, he continued:

> should the several parts of the composition be always apexed in pyramids? Why should the highest light be always on the principal figure? Why make one corner of the picture always in shade? For what reason is the sky in a daylight picture made as black as night? And this even when seen through the window of a chamber where the strong light comes from no other source than the same sky shining through the opposite window.

Together, Hunt and Millais also discovered the poetry of John Keats, whose blend of sensuousness and romance fired their imaginations, evoking vivid images. The figures that Millais helped to paint in Hunt's picture were from the final scene of Keats's 'The Eve of St Agnes', in which the young lovers elope:

> *The chains lie silent on the footworn stones;*
> *The key turns, and the door upon its hinges groans.*

ABOVE: *Portrait of Millais as a young man, by William Henry Hunt. The Millais family were old-established residents of Jersey in the Channel Islands, and 'Johnny' an infant prodigy, the youngest-ever student of the Royal Academy Schools.*

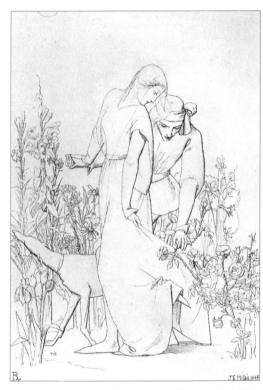

ABOVE: Lovers by a Rosebush *(1848) inscribed by Millais and presented 'to his PR brother Dante Gabriel Rossetti'. An early Pre-Raphaelite drawing, the slight stiffness and flattened perspective effectively evoke an atmosphere of medieval romance.*

And they are gone: ay, ages long ago
These lovers fled away into the storm ...

In May 1848 the picture was sent to the Royal Academy. Here it absorbed the attention of the twenty-year-old Dante Gabriel Rossetti. In Hunt's words:

> Rossetti came up to me, repeating with emphasis his praise, and loudly declaring that my picture ... was the best in the collection. Probably the fact that the subject was taken from Keats made him the more unrestrained ...
> A few days more, and Rossetti was in my studio.

After a promising start, Rossetti had dropped out of the Royal Academy Schools, bored with the diligent but tedious training. He was enthusiastic about new departures in art, and over the summer a warm and sometimes boisterous friendship with Hunt developed.

'Dear William,' wrote Rossetti to his brother on 30 August:

> Hunt and I have prepared a list of Immortals forming our creed, and to be pasted up in our study [studio] for the affixing of all decent fellows' signatures. It has already caused considerable horror among our acquaintance. I suppose we shall have to keep a hair-brush. The list contains four distinct classes of Immortality; in the first of which three stars are attached to each name, in the second two, in the third one, and in the fourth none ... We are also about to transcribe various passages from our poets, together with forcible and correct sentiments, to be stuck up about the walls.

Rossetti's father was a political refugee from Italy, whose hopes of returning home had been raised and then dashed by the events of 1848. Hunt later painted a vivid word-picture of the Rossetti home:

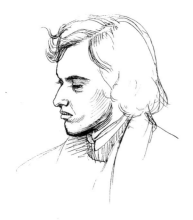

ABOVE: *'His nose was aquiline, delicate, with a depression shaping the bridge, the nostrils full, the brow rounded and prominent and the line of the jaw angular,' wrote Holman Hunt, who made this portrait sketch of Rossetti in the early days of the Brotherhood.*

ABOVE: *Rossetti's pencil portrait of his father, Professor Gabriele Rossetti, dated 28 April 1853, showing him immersed in researches into the writings of Dante Alighieri, after whom the artist was named.*

The father arose to receive me from a group of foreigners around the fire, all escaped revolutionaries from the Continent ... The conversation was in Italian, but occasionally merged into French ... The hearth guests took it in turns to discourse, and no one had delivered many phrases ere the excitement of speaking made him rise from his chair, advance to the centre of the group and there gesticulate as I had never seen people do except on the stage ... Each orator evidently found difficulty in expressing his full anger, but when passion had done its measure in work and gesture, so that I as a stranger felt pained at not being able to join in practical sympathy, the declaimer went back to his chair, and while another was taking up the words of mourning and appeal to the too tardy heavens, the predecessor kept up the refrain of sighs and groans. When it was impossible for me to ignore the distress of the alien company, Gabriel and William shrugged their shoulders, the latter with a languid sign of commiseration, saying it was generally so.

'It was a novelty to me,' he went on:

to begin dinner with maccaroni, and there were other dishes and dressings not usual on English tables ... At the conclusion of the meal the brothers and I saw the remainder of the company established at dominoes and chess before the arrival of the other members for the P.R.B. meeting upstairs.

Some time that autumn the three friends looked over some reproductions of modern German art, together with a book of engravings of fourteenth-century frescoes in the Campo Santo in Pisa. As Hunt explained:

It was probably the finding of this book at this special time which caused the establishment of the Pre-Raphaelite Brotherhood. Millais, Rossetti and myself were all seeking some

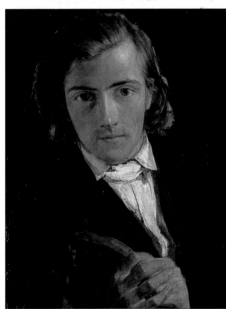

BELOW: Frederic George Stephens, P.R.B., *painted by Holman Hunt in 1847. Stephens's son, usually known as 'Holly', was named after Hunt. 'Golden Holly bears a rose ... to cheer an old friend's eyes and nose,' wrote Christina Rossetti with thanks for a gift.*

sure ground, some starting point for our new art ... As we searched through this book of engravings, we found in them or thought we found, that freedom from corruption, pride and disease for which we sought. Here there was at least no trace of decline, no conventionality, no arrogance ... Think what a revelation it was to find such work at such a moment, and to recognize it with the triple enthusiasm of our three spirits.

ABOVE: *'When we agreed to use the letters P.R.B. as our insignia, we made each member solemnly promise to keep its meaning strictly secret,' wrote Holman Hunt. This drawing of the brothers was copied from Hunt's notebook by Arthur Hughes.*

With the brio of youth, they dismissed all post-Renaissance art in the tradition of Raphael, and criticized most living painters as deplorably 'sloshy' – lazy, conventional, boring. Millais even mocked the renowned founder of the Royal Academy, whose *Discourses* still formed the basis of its teaching, as Sir 'Sloshua' Reynolds.

And so, at an inspired moment no-one could afterwards exactly recall, they hit on the idea of a semi-secret group, with which they aimed to startle the art world. They would exhibit pictures with the mysterious initials 'P.R.B' attached to their names. Quickly recruited to make up the mystic number of seven were painters James Collinson and Fred Stephens, sculptor Thomas Woolner and Gabriel's brother William Rossetti, aspiring art critic.

As soon as the Pre-Raphaelite Brotherhood was formed, it became among them the focus of boundless companionship, as William recalled:

> We were really like brothers, continually together and confiding to one another all experience bearing on questions of art and literature and many affecting us as individuals. We dropped using the term 'Esquire' on letters, and substituted 'P.R.B.' ... There were monthly meetings, at the houses and studios of the various members in succession; occasionally a moonlight walk or a night on the Thames. Beyond this, but very few days can

BELOW: *William Holman Hunt, aged eighteen, by himself, showing his perceived resemblance to William Hogarth, another of the P.R.B. 'Immortals', though not an artist whose style they emulated.*

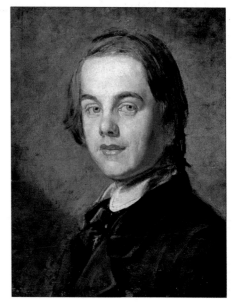

have passed when two or more P.R.Bs did not foregather for one purpose or another ... We had our thoughts, our unrestrained converse, our studies, aspirations, and actual doings; and for every P.R.B. to drink a cup of tea or coffee, or a glass or two of beer, in the company of other P.R.Bs, with or without the accompaniment of tobacco ... was a heart-relished luxury ... Those were the days of youth, and each man in the company, even if he did not project great things of his own, revelled in poetry or sunned himself in art.

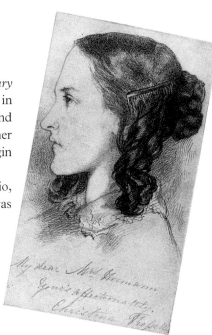

RIGHT: Christina Rossetti, aged sixteen, drawn by her brother Dante Gabriel. This portrait was presented to Christina's good friend Amelia Heimann. An almost identical version of the same drawing was bound into Christina's Verses, *printed by her grandfather in 1847.*

Rossetti's first painting in the new mode was *The Girlhood of Mary Virgin*, derived from the traditional depiction of this subject in European art but treated in what he described as a 'more probable and at the same time less commonplace' manner. He used his own mother as the model for St Anne, and his younger sister Christina for the Virgin – 'her appearance being excellently adapted to my purpose'.

Seeing this painting on the easel as Rossetti worked in Hunt's studio, a visitor noted that 'this daring performance of a boy turning what was naturally a lyrical subject into a picture' was something quite new:

He was painting in oils with water-colour brushes, as thinly as in water-colour, on canvas which he had primed with white till the surface was as smooth as cardboard, and every tint remained transparent. I saw at once too that he was not an orthodox boy, but acting purely from the aesthetic motive: the mixture of genius and dilettanteism of both the men shut me up for the moment, and whetted my curiosity.

The visitor was William Bell Scott, one of the painters schooled in an older tradition who recognized the revolutionary nature of P.R.B. practice. The unusual technique was that of painting transparently on a still-wet ground to make the colours luminous. This was painstaking work, impossible to correct by overpainting without altering the hues.

Another, older painter, who became a close friend and mentor to the group, was Ford Madox Brown, whose picture of Chaucer reading to the Court of Edward III they had already admired. Other, younger painters attracted to the new style included Walter Deverell, Charles Collins and Arthur Hughes.

The boys of the Brotherhood were full of high spirits. 'Apropos of death Hunt and I are going to get up among our acquaintance a Mutual Suicide Association,' Gabriel told William, facetiously:

any member, being weary of life, may call at any time upon another to cut his throat for him. It is all of course to be done very quietly, without weeping or gnashing of teeth. I, for instance, am to go in and say, 'I say, Hunt, just stop painting that head a minute, and cut my throat'; to which he will respond by telling the model to keep the position as he shall be only a moment, and having done his duty, will proceed with the painting.

They did not take themselves too seriously. One evening William wrote to Stephens in verse:

It is now past the hour of 12;
Gabriel's dozing in his chair.
And so this letter I will shelve
As soon as may be, dear Brother.
Not that I mean to go to bed
Quite yet. I have the P. R. B
Diary to write up instead ...
And yet, dear brother, I confess
Your full-leaved letter would deserve
A better answer. Nevertheless
Take this. And think it but a curve
Of the broad circle wherewith I

ABOVE: *William Michael Rossetti, drawn by his brother in April 1853 for Thomas Woolner. William Rossetti kept the P.R.B. Journal and edited* The Germ. *In 1874 he married Lucy, elder daughter of Ford Madox Brown.*

ABOVE: *Frances Lavinia Rossetti, aged fifty four, by her son. In her own words, Frances Rossetti had 'a passion for intellect' and encouraged her children to become distinguished in art and literature.*

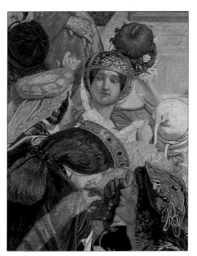

ABOVE: *Detail from Ford Madox Brown's* Chaucer, *showing Thomas of Woodstock whispering to Lady de Bohun, in front of Philippa and Catharine Roet. The head of Thomas was studied from Walter Deverell and that of Catharine from Emma Hill.*

RIGHT: Geoffrey Chaucer Reading to the Court of Edward III, on the Black Prince's 45th Birthday *(1851) by Ford Madox Brown. Gabriel Rossetti, whom Brown thought was 'the very image' of Chaucer, sat for the main figure.*

Encircle you in P.R.B-
hood. And so truly now, Good bye.
Yours, I to you as you to me.

From May 1849 William was appointed official scribe, charged with keeping a record of P.R.B. achievement and endeavour. There were plans and dreams. The Brotherhood even went to inspect a house by the Thames at Chelsea, with the idea of establishing a communal residence:

TUESDAY 6TH NOVEMBER 1849
It is capable of furnishing 4 good studios, with a bed room and a little room that would do for a library attached to each. There is also an excellent look out on the river. The rent £70. In the evening we all (except Millais) congregated at Woolner's and discussed the matter. Gabriel, Hunt and myself think of going at once, and Stephens and Collinson would join after April. We think likewise of getting Deverell. 'P.R.B' might be written on the bell, and stand for 'please ring the bell' to the profane. Woolner being engaged out and his stove refusing to be lighted, we came back to this house, where we finished the talk and the evening, Woolner also coming in soon after … we spoke of omitting anything at all referring to politics or religion into our magazine.

But the Chelsea house proved too large and too expensive. Four days later Hunt found a smaller studio close to the river, and Rossetti a similar place behind Oxford Street.

SATURDAY 10TH
Gabriel found a studio at no. 72 Newman Street. The rent asked is £30, but he succeeded in bringing it down to £28.

'Our magazine' was *The Germ*, a short-lived but historic publication produced by the P.R.B. and their friends in the early months of 1850. Much debate took place over the title – 'it is an important matter.

There is something in a name' – and suggestions included 'The Harbinger', 'The Progressist' and 'The Seed'. The bold yet tentative subtitle was 'Thoughts towards Nature in Poetry, Literature and Art', and for the cover William penned an explanatory sonnet:

> *When whoso hath a little thought*
> *Will plainly think the thought which is in him –*
> *Not imaging another's bright or dim,*
> *Not mangling with new words what others taught ...*
> *Be not too keen to cry `so this is all –*
> *A thing I might myself have thought as well,*
> *But would not say it, for it was not worth!'*
> *Ask: `Is this truth?' For is it still to tell*
> *That, be the theme a point or the whole earth,*
> *Truth is a circle, perfect, great or small?*

The poet Coventry Patmore, author of *The Angel in the House*, favoured *The Germ* with a contribution, but the best things in it were written by Christina Rossetti.

Christina was the youngest of the four Rossettis and the most gifted, poetically. Not yet twenty, she was engaged to James Collinson, P.R.B. *The Germ* carried the 'Song' that became one of her most famous lyrics, with its characteristic blend of melancholy and insouciance:

> *Oh! roses for the flush of youth*
> *And laurel for the perfect prime;*
> *But pluck an ivy branch for me*
> *Grown old before my time.*
>
> *Oh! violets for the grave of youth,*
> *And bay for those dead in their prime;*
> *Give me the withered leaves I chose*
> *Before in the old time.*

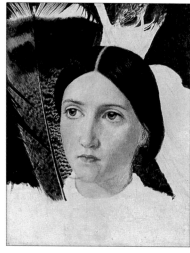

ABOVE: *Unfinished portrait of Christina Rossetti (1857) by John Brett. 'My heart is like a singing bird Whose nest is in a watered shoot,' wrote Christina in an unusually joyful poetic mood, 'Because the birthday of my life is come, My love is come to me.'*

ABOVE: *Head study for a figure in*
Isabella *by Millais (see page 23),*
probably drawn from F.G. Stephens.
One of the themes of Keats's poem
is true love in defiance of rank, a
romantic ideal that inspired several of
the Pre-Raphaelites' own marriages.

For *The Germ*, Gabriel contributed his poem 'The Blessed Damozel' and also wrote 'Hand and Soul', a story about a thirteenth-century Italian artist named Chiaro dell'Erma, the fictional forebear, as it were, of the P.R.B. Chiaro paints first for worldly fame, and next for unworldly faith; both leave him dissatisfied. Then he has a vision of 'a fair woman, that was his soul', who bids him to combine both the human and the divine in his art. The result is a small but exquisite image, outlining in words the Pre-Raphaelite ideal:

> the figure of a woman, clad to the hands and feet with a green and
> grey raiment, chaste and early in its fashion, but exceedingly simple.
> She is standing; her hands are held together lightly, and her eyes set
> earnestly open.

So far the great P.R.B. enterprise had attracted little attention from the public, though the younger generation of artists and writers was already aware of their work.

'If you can, get a sight of the "Germ",' wrote poet Bessie Parkes to the painter Anna Howitt:

> a small publication put forth by a set of crazy poetical young men in
> London, artists mostly, who call themselves the 'Pre Raphaelian
> brethren'[*sic*] and seek in all things for the 'simplicity of nature' which
> is uncommonly simple and soft. But they are full of true feeling in spite
> of their craziness and in one of the first numbers is a lovely poem
> called 'The Blessed Damozel' (what a title) worthy of the very best
> company ... Of course their confederation (one of them wanted to
> hang out a board with the P.R.B.!) must come to an end, but I expect
> something from the component atoms.

Millais's first Pre-Raphaelite picture was the romantic *Isabella*, from Keats's poem 'Isabella or The Pot of Basil'. In this he inserted the P.R.B. initials, both after his signature and on the carved base of

ABOVE: *Head study for the serving-man*
in Isabella, *thought to be drawn from*
an art student at the Royal Academy.
Absolute fidelity to nature involved
finding models whose features matched
those of the characters depicted, as
in casting a play.

Isabella's stool. Among those who posed for the various figures were Fred Stephens and both Rossettis (William for Lorenzo), while Millais's sister-in-law Mary Hodgkinson sat for Isabella.

Models were always a difficulty. At a time when artists' studios were held to be dens of immorality, the best female models were hard to find and reluctant to sit. One landlord stipulated that models were to be kept under gentlemanly restraint, 'as some artists sacrifice the dignity of art to the baseness of passion'. Once, Gabriel, William and Woolner went out to meet Millais, who with Hunt and another friend was 'parading Tottenham Court Road' in search of models. They saw 'one or two women adaptable', but did not muster the necessary courage to address them, lest the women call 'Police' at the insult of being accosted like common prostitutes.

Ruskin later wrote of the precise naturalism of their subjects:

every Pre-Raphaelite landscape background is painted to the last touch, in the open air, from the thing itself. Every Pre-Raphaelite figure, however studied in expression, is a true portrait of some living person. Every minute accessory is painted in the same manner.

Hunt, who was always most in earnest, stuck steadfastly to these principles. For his new picture, a scene from the Dark Ages showing a Christian missionary being saved from the Druids, he went in search of authentic models, as the P.R.B. Journal records:

MONDAY 25 MARCH

He has been on a foraging expedition to Battersea Fields, after gipsies, on the recommendation of one who sat to him for his druid's head, as he wants to get some woman with good hands of a proper savage brownness. He finds himself quite disabused of old ideas concerning 'sloshiness' and commonplace of gipsies, having fallen in with some of the most

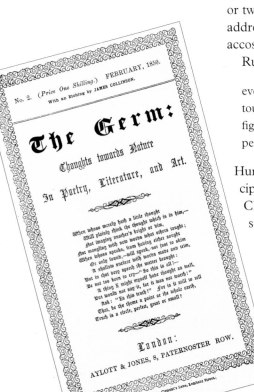

BELOW: The Germ (1850), the short-lived P.R.B. magazine. Each issue included an etching as well as poems, prose and criticism. Money ran out very quickly and only four issues appeared.

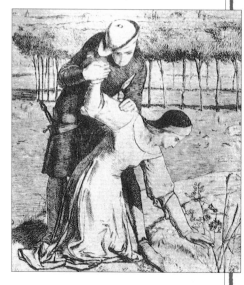

ABOVE: My Beautiful Lady, Holman Hunt's illustration to a poem by Thomas Woolner in The Germ:
... one day I saw my lady pull
Some weeds up near a little brook,
Which home most carefully she took,
Then shut them in a book.

extraordinary-looking people conceivable. He found a very beautiful woman for what he wants, fit for Cleopatra; she consented to sit for £5 an hour, but finally came down to a shilling, and fixed a day to come.

Another good model was a young milliner whom Deverell had 'discovered' and who had dreams of being an artist herself.

> She was tall and slender, with red coppery hair and bright consumptive complexion, though in these early years she had no striking signs of ill-health. She was exceedingly quiet, speaking very little. She had read Tennyson, having first come to know something about him by finding one or two of his poems on a piece of paper which she brought home to her mother wrapped in a pat of butter ... Her drawings were very beautiful, but without force.

Her name was Elizabeth Siddal, familiarly known among the artists as 'Miss Sid', or 'the Sid', and then as Lizzie. She sat to Deverell and to Hunt, for his *A Converted British Family Sheltering a Christian Missionary* and also for the figure of Sylvia in his scene from *The Two Gentlemen of Verona*. Soon she was well known in the studios.

Her starring role, as it were, was in Millais's picture of Ophelia floating down the river to her death, singing (see page 10). Near Kingston in Surrey the artist found the exact spot for his background, under some willows on the bank of a small river, and here he painted in the flowers and foliage of his picture. Back in the studio over the winter, Lizzie was hired to pose for Shakespeare's dying heroine. As Arthur Hughes recalled:

> Miss Siddal had a trying experience whilst acting as a model for 'Ophelia'. In order that the artist might get the proper set of the garments in water and the right atmosphere and aqueous effects, she had to lie in a large bath filled with water, which was kept at an even temperature by lamps placed beneath. One day, just as the picture was

ABOVE: *Study for the figure draining a glass of wine in Millais's* Isabella, *drawn from D.G. Rossetti in the winter of 1848–9.*

ABOVE: *Detail showing 'Fair Isabel', the heroine of Keats's poem. The model was Millais's sister-in-law Mary Hodgkinson.*

RIGHT: Isabella *(1849) by John Everett Millais, illustrating the opening scene of Keats's poem. On the terrace the terracotta pot containing a basil plant refers ominously forward to the tragedy. On Isabella's stool are the carved initials 'PRB'.*

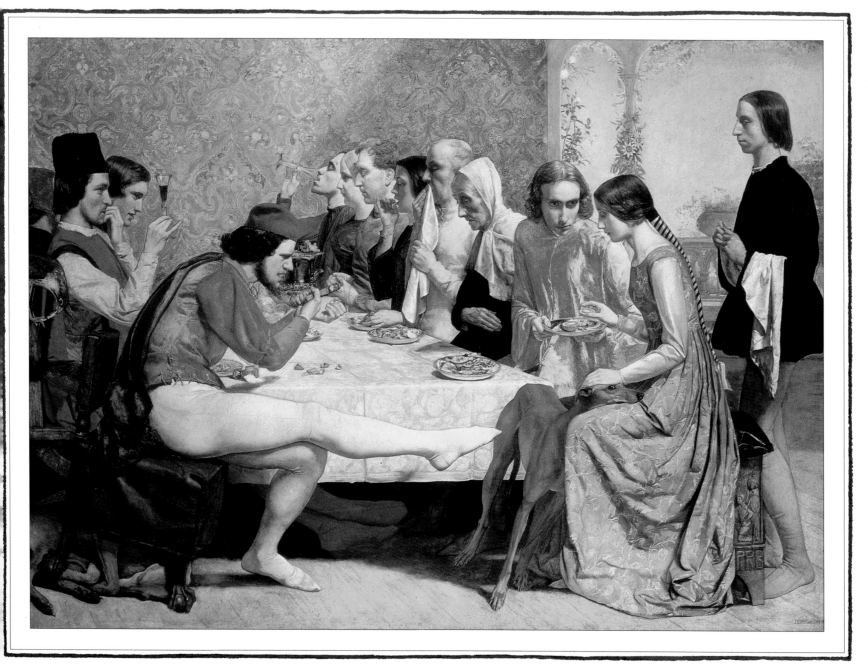

nearly finished, the lamps went out unnoticed by the artist, who was so intensely absorbed in his work that he thought of nothing else, and the poor lady was kept floating in the cold water till she was quite benumbed. She herself never complained of this, but the result was she contracted a severe cold, and her father wrote to Millais, threatening him with an action for £50 damages for his carelessness. Eventually the matter was satisfactorily compromised. Millais paid the doctor's bill; and Miss Siddal, quickly recovered, was none the worse for her cold bath.

Over the winter of 1849–50 the P.R.B. worked with added application, determined to make their mark in the coming exhibition season. The P.R.B. Journal chronicles their efforts:

1 NOVEMBER 1849
In the morning Gabriel called on Millais, and saw a design he has made of the Holy Family. Christ, having pricked his hand with a nail (in symbol of the nailing to the cross) is being anxiously examined by Joseph, who is pulling his hand backwards, while he, unheeding this, kisses the Virgin with his arm round her neck.

RIGHT: *Study for the head of Ophelia (1852) by Millais (see page 10), drawn from Elizabeth Siddal, at the age of twenty-three. A fine likeness, according to William Rossetti, showing Lizzie's fragile beauty and fair, translucent skin.*

24 NOVEMBER

Gabriel began making a sketch for the *Annunciation*. The Virgin is to be in bed, but without any bed clothes on, an arrangement which may be justified in consideration of the hot climate, and the Angel ... is to be presenting a lily to her. The picture ... will be almost entirely white.

The Journal records on 11 February:

This was a P.R.B. night at Millais's, where all were present except Collinson. Millais says he has done several hands, feet, legs, etc, in his picture, but it is for the present kept invisible. Stephens has been prevented as yet from beginning his picture [of Patient Griselda, from Chaucer] by the unpunctuality of models.

13 FEBRUARY

Gabriel, Bernard Smith and I [William Rossetti] spent the evening with Woolner, who goes on at his statue. He showed us a daguerreotype of Tennyson, which has been lent to him. The third edition is out of *The Princess* which we saw on Monday at Millais's, Stephens having bought it.

14 FEBRUARY

Hunt is progressing rapidly. He has put in two or three more of the figures in the background, has gone on with the two savages at the door, and the girl stooping, begun the rows of cabbages, drawn in the principal woman (whom he has altered from old to young, making the woman behind the chair old) and is now painting the preacher's red drapery.

Lizzie Siddal posed for the young woman in the *Christian Family*, wearing a rough hessian cape.

RIGHT: *Study for the Virgin in* Ecce Ancilla Domini! *(1850), also known as* The Annunciation, *by Rossetti, apparently drawn from his sister Christina, although she did not usually sit for figures and the visible arm looks too thick.*

The young lad named Noel Humphreys who modelled for the figure of Christ in Millais's picture also kept a diary:

18 FEBRUARY 1850
At four o'clock we received a letter from Mr John Millais (an artist) reminding Mama of her promise to let me go and sit for Christ in one of his pictures.

19 FEBRUARY
The first day I arrived there at 10. John showed me his three pictures ... the last which I sat for was a scriptural subject, Christ having been working in his father's carpenter's shop has cut his hand and John the

RIGHT: A Converted British Family Sheltering a Christian Missionary from Persecution by the Druids *(1850) by Holman Hunt, depicting the sort of scene that was believed to have happened in the early days of the Christian conversion of Britain. In the background are some standing stones and a Druid mob.*

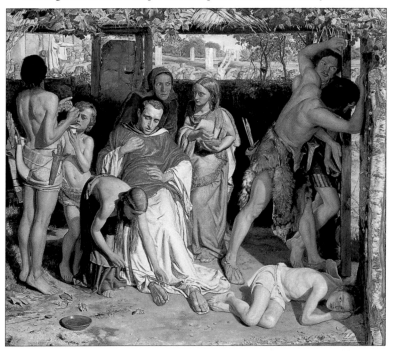

RIGHT: The Girlhood of Mary Virgin *(1849) by Dante Gabriel Rossetti, exhibited with sonnets explaining both subject and symbolism:*
Her gifts were simpleness of intellect
And supreme patience. From her mother's knee
Faithful and holy ... as it were
An angel-watered lily...

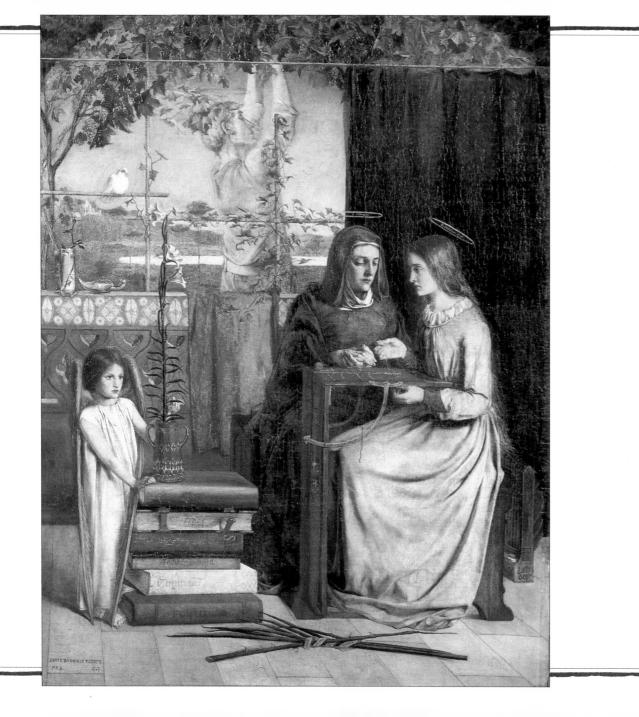

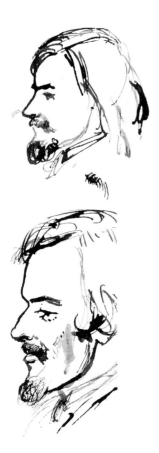

Baptist is advancing with a basin of water emblamatical [*sic*] of Baptism. I sat from half past ten to six o'clock when we had dinner. I went again both Tuesday and Wednesday. After dinner on those days I had some games of cards . On the first day John began the face; on the second finished the neck and began the hair.

7 MARCH
Directly after breakfast I walked down to Mr J. Millais to sit for him for the last time. He finished both the hands and wanting to imitate a scratch in Christ's hand he pricked his own finger to paint the exact colour of blood; he painted it with Vermilion, Crimson Madder and Madder Lake.

The rest of the P.R.B. spent March 1850 trying and failing to rescue *The Germ*, which finally 'died with its fourth number, leaving us a legacy of Tuppers' bill – £33 odd ... Placards were posted and paraded about daily before the Academy – but to no effect. *The Germ* was doomed and succumbed to its doom.'

Then things grew tenser as the exhibition deadlines approached, as William Rossetti recorded in the P.R.B. Journal on 7 April:

Portrait sketches by Holman Hunt of F.G. Stephens (left top), D.G. Rossetti (left bottom) and J.E. Millais (above).

For this morning I was engaged to sit to Hunt. He had intended to paint from me the head of the monk flying in the background; but instead of this, I sat for the working of the head and hands of the principal figure ... He has put in part of a corn-field that cuts across the legs of the outside monk; and there remains now scarcely any uncovered canvas; he has, however, a tremendous deal still to do for so short a time ... Collinson came in, and says he's done a vast amount of work since I last saw his picture [*Answering the Emigrant's Letter*] ... I did not get home till too late to sit to Gabriel, who had wanted me for a final retouching of the Angel's head; he has got some spirits of wine and chloride of something to make the flame for the Angel's feet.

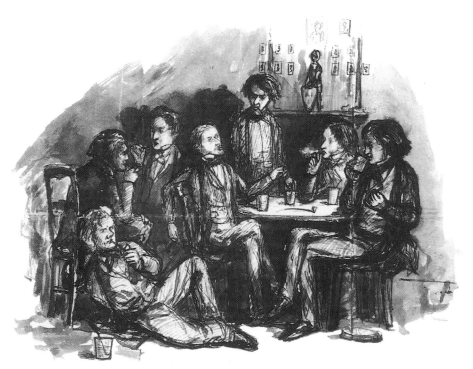

ABOVE: *'The reunion represented was held the other night', wrote Rossetti to Deverell on 30 August 1851. 'There were a great number of fellows present besides those represented but the paper is such beastly stuff to draw upon that I had not the pluck to put everyone in, and I fear that some may already be unrecognizable.'*

MONDAY 8TH

Gabriel went to see Millais's picture, which is now finished. He himself had to work hard at his background all day, beside doing something to the Virgin's head; and had Deverell to assist him in doing certain things.

At this point the P.R.B. Journal broke off, temporarily, as if the anxiety were too much for William. They were all working feverishly. It has been said that the P.R.Bs spent more time talking than painting, and certainly Bessie Parkes called them crazy and poetical. But this was in admiration, and in the event it was not craziness but critical attack that first fractured the Brotherhood.

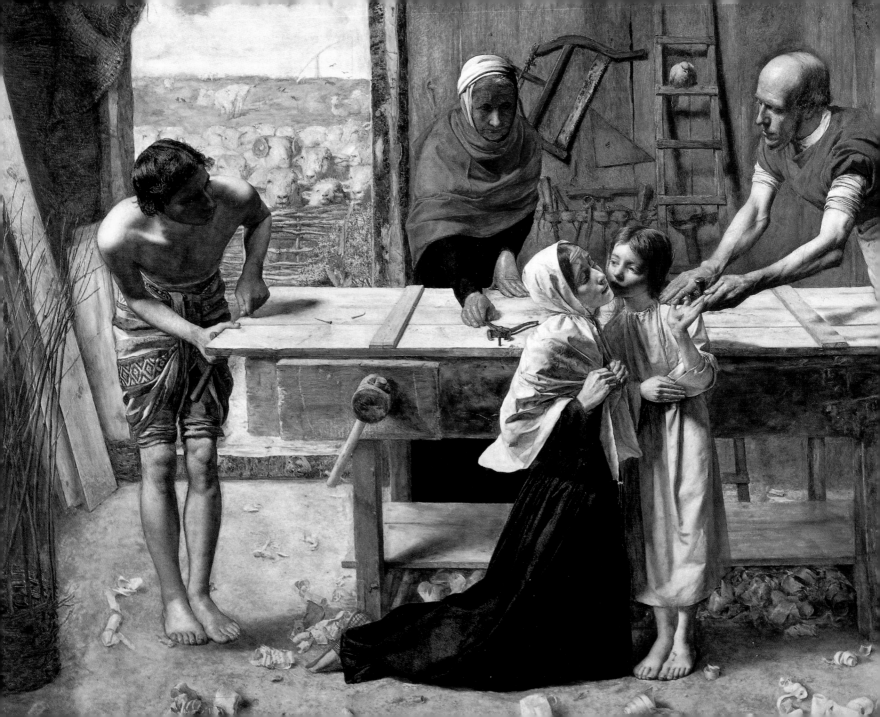

UNDER ATTACK

WHEN THE P.R.B. JOURNAL RESUMED in July 1850, William Rossetti summarized the events of the intervening weeks. Millais's *Christ in the Carpenter's Shop*, Hunt's *A Converted British Family Sheltering a Christian Missionary from Persecution by the Druids* and Collinson's *Answering the Emigrant's Letter* were all hung at the Royal Academy, while Gabriel, fearing rejection, sent his painting to another gallery, re-titling it *Ecce Ancilla Domini!*, from the opening words of the Virgin Mary's reply to the Angel, 'Behold the Handmaid'.

Christ in the Carpenter's Shop sold for £350, but also provoked hostility, as the Journal describes:

Millais's picture has been the signal for a perfect crusade against the P.R.B. The mystic letters with their signification have appeared in all kinds of papers ... the designation is now so notorious that all conceal-ment is at an end. *The Athenaeum* opened with a savage attack on Gabriel, who answered it in a letter which the editor did not think it expedient to publish ... In the *Times*, the *Examiner*, the *Daily News*, even to Dickens' *Household Words*, where a leader was devoted to the P.R.B. and devoted them to the infernal gods, the attack on Millais has been the most virulent and audacious ... Indeed, the P.R.B. has unquestionably been one of the topics of the season. The 'notoriety' of Millais' picture

OPPOSITE: **Christ in the Carpenter's Shop** *(1850) by Millais. The artist arranged to paint in a real carpenter's workshop near Oxford Street, having a bed set up there in order to start work early in the morning.*

BELOW: *Preparatory drawing for the painting, showing how the composition evolved.*

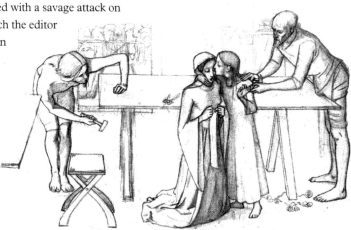

may be evidenced by the fact, received from undoubted authority, of the Queen's having sent to have it brought to her from the walls of the R.A.

'I hope it will not have any bad effects on her mind,' joked Millais to Hunt on hearing of the Queen's request. But he was shaken by the attack, which among other things accused him of 'pictorial blasphemy' in depicting sacred figures in such a realistic manner. It was 'plainly revolting', thundered *The Times*:

> The attempt to associate the holy family with the meanest details of a carpenter's shop, with no conceivable omission of misery, of dirt, of even disease, all finished with the same loathsome minuteness, is disgusting; and with a surprising power of imitation, this picture serves to show how far mere imitation may fall short, by dryness and conceit, of all dignity and truth.

Hunt's picture was criticized for copying 'all the objectionable peculiarities of the infancy of art' in the time of the Italian Primitives (an unintended compliment), and the whole P.R.B. for the 'abruptness, singularity, uncouthness ... with which they play for fame'.

As avant-garde artists have always known, outrage often provides the pathway to fame. But the P.R. Brethren needed to sell their pictures, and hostile criticism was financially damaging. 'Hunt's picture, Gabriel's and Collinson's remain unsold,' commented William despondently.

It also resulted in the defection of Collinson from their ranks. As a convert to the Roman Catholic faith, he felt uneasy at being associated with those accused of bringing dishonour to God's holy saints, 'if not absolutely to bring their sanctity into ridicule'. He therefore wished to resign from the P.R.B. and hoped no-one would try to change his mind. No-one did.

ABOVE: *'Varnishing Day at the RA' (1851). 'Millais came back with me early from the Academy and took up a pen and sketched the scene representing our rivals' wrath at our pictures, with others engaged in touching up their own work,' wrote Hunt.*

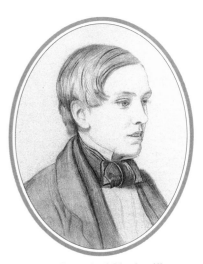

ABOVE: *Portrait of Charles Allston Collins by Holman Hunt, July 1852. In 1850 Collins was proposed for membership of the P.R.B. by Millais, supported by Hunt, Rossetti and Stephens, but vetoed by Woolner and William Rossetti.*

The person most injured by his decision was Christina, whose engagement was simultaneously cancelled by Collinson's re-affirmed Catholic faith. He sent her a sonnet presenting the choice as that between love and faith. Christina was heartbroken. Three of the verses of her poem 'Memory' seem to commemorate her unhappiness:

> I nursed it in my bosom while it lived,
> I hid it in my heart when it was dead;
> In joy I sat alone, even so I grieved
> Alone, and nothing said.
>
> None know the choice I made; I make it still.
> None know the choice I made, and broke my heart
> Breaking mine idol: I have braced my will
> Once, chosen for once my part.
>
> I broke it at a blow; I laid it cold,
> Crushed in my deep heart where it used to live.
> My heart dies inch by inch; the time grows old
> Grows old, in which I grieve.

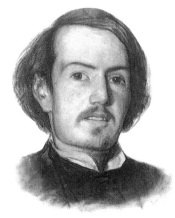

ABOVE: *Walter Howell Deverell, already terminally ill when drawn by Holman Hunt in 1853. In 1850 Deverell exhibited a scene from* Twelfth Night, *in which Lizzie Siddal sat for Viola.*

Of the various candidates who might fill the P.R.B. vacancy, Walter Deverell was the most eligible. He had been a partner in *The Germ* and was, wrote William Rossetti, 'very handsome and winning', while to William Bell Scott he was a 'morning-bright Apollo'. Sadly, Deverell suffered from kidney disease, and never lived to fulfil his promise.

Another associate was Charles Collins, brother to the author Wilkie Collins and close friend of Millais, who was working on a picture of a novice nun in a convent garden. The flowers were painted from nature – 'very slowly' – in the garden of Oxford University Press, and 'one of the lilies occupied a whole day'. Millais himself was painting *The Return of the Dove to the Ark*, which contains an olive branch symbolizing hope and salvation, just as the novice nun's passion flower stands for sacrifice

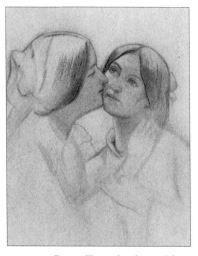

ABOVE: *Deverell's study of two girls embracing, dated 9 May 1853 and given to F.G. Stephens by the artist's sisters soon after his death; it was perhaps drawn from them, as a study for a never-completed painting.*

and redemption. In secular vein Millais was also busy with *Mariana*, based on Tennyson's poem:

> All day within the dreamy house
> The doors upon their hinges creak'd;
> The blue fly sung in the pane; the mouse
> Behind the mouldering wainscot shriek'd,
> Or from the crevise peered about ...
> She only said 'My life is dreary.
> He cometh not' she said;
> She said 'I am aweary, aweary,
> I would that I were dead!'

One day Millais found himself in unaccustomed idleness owing to a model's absence. As the tale was related in his family:

he naturally disliked being stopped in his work in this way, and the only thing he could think of was to sketch the mouse that 'Behind the mouldering wainscot shriek'd'... But where was the mouse to paint from? Millais' father, who had just come in, thought of scouring the country in search of one, but at that moment an obliging mouse ran across the floor and hid behind a portfolio. Quick as lightning Millais gave the portfolio a kick, and on removing it the poor mouse was found quite dead in the best possible position for drawing it.

Rossetti, Stephens and Hunt had been to Knole in Kent, endeavouring to paint from nature despite English weather. As Gabriel wrote home:

I reached here yesterday evening and seem to have come in for the most rascally fortnight of the year. The wet seems regularly established ... I went out this morning with Hunt in search of an eligible spot and found what I wanted, but was unable to make more than a sketch since, after an interval of extreme anguish, Hunt and myself were

ABOVE: Convent Thoughts *(1851) by Charles Allston Collins. The novice is shown contemplating a passion flower, symbol of Christ's crucifixion. Collins worked very slowly: 'a flower of one of the lilies occupied a whole day'.*

RIGHT: Mariana *(1851) by John Everett Millais. Another image of female confinement. The windows derive from ones in Merton College, Oxford, while the snowdrop is the emblem of St Agnes.*

ABOVE: *Detail of the missal held by the nun in* Convent Thoughts, *based on a fifteenth-century Book of Hours in the Soane Museum, London, opened to show images of the Annunciation (left) and Passion (right).*

obliged to beat a retreat, soaked to the bone ... Will you therefore take the trouble to send me somehow my other breeches?

'Hunt gets on swimmingly,' he added, 'indeed, a full inch above the ankles.' The next day weather conditions were a little better:

> Today I began painting on my picture in the park; and began to profit by the views of the public thereon. One man told another that I was drawing a map ... One boy was kicked by another for insulting me by doubting that my landscape was meant for a deer. I saw the back of a pair of top boots and a cutaway coat; Lord Amherst, I was told, was sneaking inside ... The cold here is awful when it does not rain, and then the rain is awful. 'And what shall guard me but my naked love?' – and a railway rug.

Hunt completed a fine woodland backdrop – 'the ground all covered with the red autumn leaves' – for his scene from *The Two Gentlemen of Verona*. Gabriel managed a narrow line of trees and then gave up, defeated by dampness and onlookers. It was his only attempt at alfresco painting. Discouraged, he turned instead to translating Dante's *Vita Nuova* and other Italian poets of the thirteenth century.

Back in London William was getting to know Ford Madox Brown, and arguing about art and poetry. One evening he and Woolner were at Brown's studio, together with several artists of the older generation, and discussion became heated:

> The business of the meeting was punning; but when, at about 1 o'clock in the morning, we began to think of lighter and less important matters, Woolner and I had to fight fiercely for Tennyson and Browning against ... Byron, Pope, etc.

In painting, Brown was already converted to the new mode, though his style always remained distinctive. He was now struggling to complete

ABOVE: *Study of F.G. Stephens by Ford Madox Brown, for* Jesus Washing Peter's Feet *at the Last Supper. In the finished picture Christ was originally naked to the waist. People were shocked by the figure however, and Brown later painted in clothes.*

OPPOSITE: *(Top left) study of Emma Hill by Ford Madox Brown, dated 'Xmas 48', shortly after she first became Brown's model. (Bottom left) Catherine Madox Brown, aged three, by her father. Cathy inherited his artistic talent and in 1870 returned the compliment with a portrait of Brown at his easel. (Top right) Lucy Madox Brown on 5 December 1847, painted by her father. Lucy was educated by Maria Rossetti and in due course became an artist herself. (Bottom right) self-portrait by Ford Madox Brown at the age of twenty-nine. 'A vigorous-looking young man, with a face full of insight and purpose,' wrote William Rossetti.*

Chaucer Reading to the Court of Edward III, and keeping an erratically spelt diary of work in progress:

> To get this part finished for the [A]cademy I have to labour very hard and at the last worked three whole nights in one week only lying down with my cloathes on for a couple of hours ... Gabriel Rossetti sat for Chaucer beginning at 11 at night, he sitting up beside me on the scaffolding sketching while I worked. We finished about 4 in the morning ... His brother William was the troubadour.

When he saw the colour and finish of Hunt's woodland scene, Brown was overwhelmed with admiration. 'My dear Hunt,' he wrote:

> I could not pass this evening in peace if I did not write to tell you how noble I think your picture ... I do not think there is a man in England that could do a finer work ... although there are qualities in Millais which have never been attained and perhaps never again will be. If Rossetti will only work, you will form a trio which will play a great part in English art ... I wish I had seen you tonight, for I am full of your picture and should like to shake you by the hand.

He even thought of announcing his own allegiance to the Brotherhood:

> I have had serious thoughts of joining P.R.B. on my pictures this year but in the first place I am rather old to play the fool, or at least what would be thought doing so; in the next place I do not feel confident enough how [the picture of Chaucer] will look and unless very much liked I would not do it; but the best reason against it is that we may be of more service to each other as we are than openly bound together.

Brown's next picture was *Jesus Washing Peter's Feet*, at the Last Supper, which seems partly inspired by both Millais's *The Carpenter's Shop* and Hunt's *British Family*. A fortnight before sending in the picture to the

Royal Academy, Brown gave it up in despair, only to be persuaded by Millais to resume; whereupon Brown:

> painted the heads of Peter, Christ and John ... also *all the other figures* of apostles, in ten days and sent it in.

Later, Brown was to blame Millais for bad advice regarding the 'wet white' technique. Hunt, however, felt that hastiness had led to the streakiness of effect.

Brown's first wife, Elizabeth, had died tragically young, leaving him with a daughter, Lucy. In 1848 he began an affair with a young model named Emma, who in due course gave birth to Catherine, usually known as Cathy. Sweet-natured but ill-educated and somewhat foolish, Emma modelled for many of Brown's female figures, including the Princess in the Chaucer picture. In 1853 the couple were married, in some secrecy lest the irregularity of Cathy's birth be revealed. Emma went to improve her education and manners, and learn to be a lady; thereafter she took her place as wife and hostess.

Gabriel sent his Italian translation to Tennyson, who complained of its 'cockney rhymes' such as 'calm' and 'arm'. He began a picture, showing Dante meeting Beatrice in Paradise, and moved with Deverell to a studio in Red Lion Square. In January 1851 the Brotherhood met with the aim of electing a new member, but could not agree. They also decided on more formality:

> Rules were also adopted for holding a P.R.B. meeting on the first Friday of every month; for fines in case of default; for a general review of each P.R.B's conduct in art at the close of the year; and making the keeping of this journal obligatory ...
>
> Millais having raised a doubt as to the propriety of our continuing to call ourselves P.R.Bs, considering the misapprehension which the name excites, it was determined that each of us should write a

ABOVE: *Detail from Hunt's* Valentine Rescuing Sylvia, *showing the woodland background painted in Knole Park, Kent. 'Hunt is progressing well,' noted Woolner on 5 November 1850, 'painting the ground all covered in red autumn-leaves.'*

RIGHT: Valentine Rescuing Sylvia from Proteus *(1851) by Holman Hunt, one of a number of Pre-Raphaelite paintings depicting the threat to female virtue by seduction or violence. The subject is taken from Shakespeare's* The Two Gentlemen of Verona.

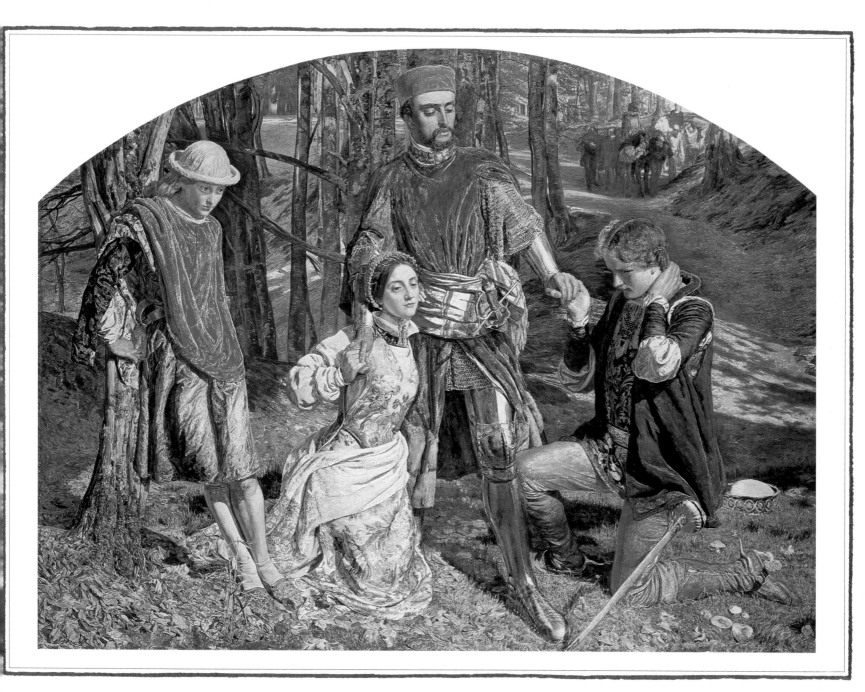

manifesto declaring the sense in which he accepts the name; to be read all together at our next meeting.

ABOVE: Girls in a Meadow *(1851) by Millais. Also known as* Picnic Scene, *this pen and ink sketch may have suggested the idea for* Spring *(see frontispiece).*

The next meeting duly took place, but no more was heard of manifestoes and no new member was elected. The opening of the 1851 Royal Academy season saw the Brethren in some trepidation, fearing another critical onslaught. This duly came. Hunt wrote that 'the storm of abuse of last year was now turned into a hurricane'. According to *The Athenaeum*:

Mr Millais exhibits his old perversity in a scene from Tennyson's 'Mariana' and 'The Return of the Dove to the Ark' ... and Mr Hunt brings up the rearward move by a scene from *The Two Gentlemen of Verona*.

The Times repeated its attack on:

that strange disorder of the mind or the eyes which continues to rage with unabated absurdity among a class of juvenile artists who style themselves P.R.B.

And it continued:

we can extend no toleration to a mere servile imitation of the cramped style, false perspective and crude colour of remote antiquity. We do not want to see ... faces bloated into apoplexy or extenuated to skeletons, colours borrowed from the jars in a druggist's shop, and expression forced into caricature.

It went on to attack 'the mistaken skill' with which the artists had depicted 'the hay which lined the lofts in Noah's Ark, the brown leaves of the coppice where Sylvia strayed and the prim vegetables of a monastic garden'.

But not all responses were abusive. As William recorded after a tour of the galleries, Millais's *Mariana* appeared to be 'a great favourite with women, one of whom said it was the best thing in the exhibition'. And on 10 May they learned that John Ruskin, whose book *The Stones of Venice* they had recently read, not only wished to purchase *The Return of the Dove*, but was writing to *The Times* in their defence.

Millais and Hunt, Ruskin proclaimed, were:

> endeavouring to paint, with the highest degree of completion, what they see in Nature without reference to conventional or established rules; but by no means to imitate the style of any past epoch. Their works are, in finish of drawing and splendour of colour, the best in the Royal Academy.

He followed this up with a second letter, which concluded:

> And so I wish them all heartily good speed, believing in sincerity that if they temper the courage and energy which they have shown in the adoption of their system with patience and discretion in pursuing it ... they may, as they gain experience, lay in our England the foundations of a school of art nobler than the world has seen for 300 years.

A few days later Woolner heard Thomas Carlyle remark on 'these Pre-Raffelites they talk of', who were said 'to copy the thing as it is', and comment approvingly, 'now there's some sense and hearty sincerity in doing this.'

RIGHT: Dante Drawing an Angel on the Anniversary of Beatrice's Death *(1849) drawn by Rossetti and given 'to his P.R. Brother' Millais, in exchange for* Lovers by a Rosebush *(see page 12). The scene is taken from the autobiographical* Vita Nuova *of Dante, with whom Rossetti identified.*

This marked the turning-point in the Pre-Raphaelites' fortunes. Hunt, Brown and the Rossettis met at Millais's studio, to discuss their next move, being all agreed that Ruskin's letter would do them good, but not certain of the propriety of thanking Ruskin personally.

Having failed to exhibit, Gabriel was excluded from both the censure and the praise. His natural position as P.R.B. leader was therefore undermined. He moved into Brown's studio, and began new subjects – Giotto painting Dante's portrait and Dante on the first anniversary of Beatrice's death, a theme that was to preoccupy him for years. 'Gabriel's picture progresses,' reported William, 'but I never see it, as he hates anyone to see or inquire after what he does while he is doing it.'

With greater feelings of success, Hunt, Millais and Collins installed themselves in lodgings on a Surrey farm, to work on their new pictures. Millais began a diary:

I am advised by Coventry Patmore to keep a diary. Commenced one forthwith. Today *October 16th* worked on my picture [*A Huguenot*]; painted nasturtiums; saw a stoat run into a hole in the garden wall; went up to it and endeavoured to lure the little beast out by mimicking a rat's or mouse's squeak – not particular which. Succeeded, to my astonishment. He came half out of the hole and looked in my face, within easy reach.

Lavinia (little daughter of landlady) I allowed to sit behind me on the box border and watch me paint, on promise of keeping excessively quiet; she complained that her seat struck very cold ... Eldest sister, Fanny,

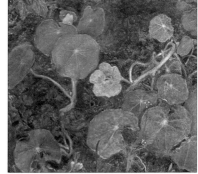

ABOVE: *Detail of nasturtiums from Millais's* A Huguenot. *The natural details in Pre-Raphaelite works were often commended for their botanical accuracy.*

LEFT: The Light of the World *(1853) by Holman Hunt. One of the most famous of all Pre-Raphaelite pictures, this image travelled the world and in engraved form found its way into many homes.*

RIGHT: A Huguenot on St Bartholomew's Day, Refusing to Shield himself from Danger *(1852) by John Everett Millais. Set in 1572, the scene popularly combined the themes of romantic love, religious integrity and English nationalism. For years Millais was asked, 'Why don't you give us the Huguenot again?'*

came and looked on too. Told me her mother says, about a quarter to six, 'There's Long-limbs (J.E.M.) whistling for his dinner.'

Three days later he wrote:

> Expected Rossetti, who never came ... Went to church. Capital sermon ... Found two servant [girls] – both very pretty – one of whom I thought of getting to sit for my picture ... Both perfectly willing to sit, evidently expecting it to be an affair of a moment.

As well as the picture of a young Huguenot refusing to wear a Catholic badge in order to escape the St Bartholomew's Day massacre, Millais was still working on *Ophelia*. At the end of October 1851 he was painting a rat, from a selection trapped or shot on the farm. To his dismay this looked first like a drowned kitten and then like a miniature lion; eventually it was painted out. The weather grew colder:

BELOW: *John 'Long-Limbs' Millais at dinner (1853) sketched by his brother William, and inscribed 'The P.R.B. Champion at his Devours'.*

OCTOBER 29TH
After breakfast began ivy on the wall; very cold and my feet wet through; at intervals came indoors and warmed them at the kitchen fire. Worked till half-past four; brought all the traps in and read *In Memoriam*.

NOVEMBER 4TH
Frightfully cold morning; snowing. Determined to build up some kind of protection against the weather wherein to paint. After breakfast superintended in person the construction of my hut – made of four hurdles, like a sentry-box, covered outside with straw. Felt a 'Robinson Crusoe' inside it, and delightfully sheltered from the wind, though rather inconvenienced at first by the straw, dust and husks flying about my picture ... This evening walked out in the orchard (beautiful moonlight night but fearfully cold) with a lantern for Hunt to see the effect before finishing background, which he intends doing by moonlight.

44

Ambitiously, Hunt was at work on a picture of Christ called *The Light of the World*, in which Jesus is shown as a nocturnal visitor, knocking at a door that stands for the human heart or soul. It was a devotional act, as he told William Bell Scott:

> I painted the picture with what I thought, unworthy though I was, to be divine command and not simply as a good subject.

Hunt, too, had a straw hut, put up in the orchard. There he sat overnight, painting 'some contorted apple tree trunks, washed with the phosphor light of a perfect moon – the shadows of the branches stained upon the sward'.

These two pictures – Millais's *Ophelia* and Hunt's *The Light of the World* – established both artists' reputations, and became their most famous works.

The insults were over. As Millais told his favourite patron, Thomas Combe, 'People had better buy my pictures now, when I am working for fame, than a few years later, when I shall be working for a wife and children.' This proved an unexpectedly prophetic remark, which came true sooner than Millais had intended.

LEFT: *'At Aunt Pat's', sketch by Charles Collins. Thomas Combe ('Uncle Tom'), of Oxford University Press, and his wife 'Mrs Pat' were early and staunch patrons and friends, especially to Millais, Hunt and Collins. In this sketch Mr Combe is at the table, with Millais sitting on the floor.*

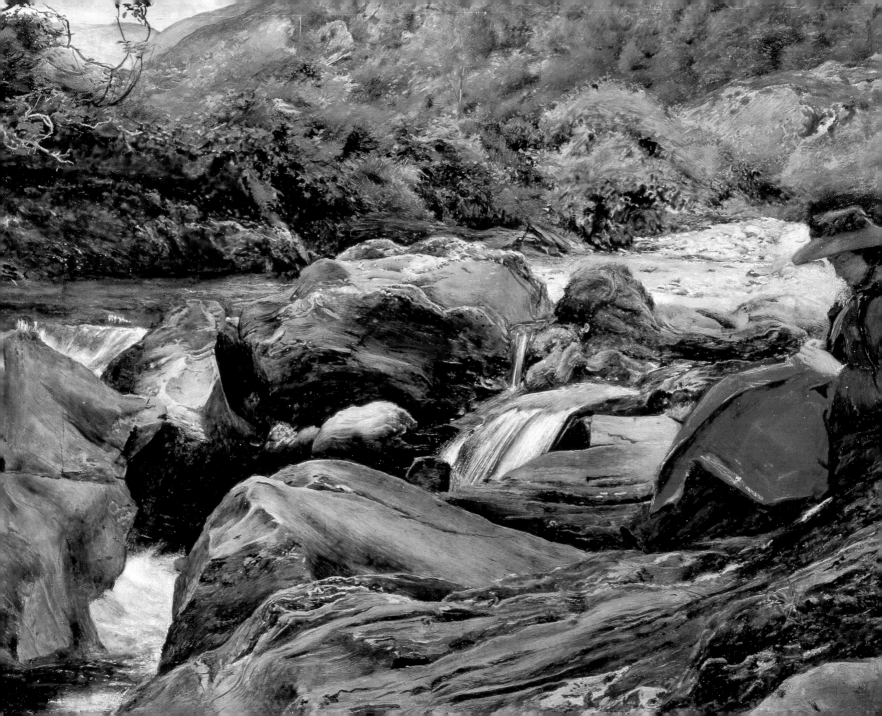

EFFIE

LEFT: The Waterfall in Glenfinlas *(1853) by Millais. 'Every day that is fine we go to paint at a rocky waterfall and take our dinner with us. Mrs Ruskin brings her work [sewing],' he wrote; 'nothing could be more delightful.'*

HAVING LEFT A SUFFICIENT TIME after Ruskin's letter to *The Times* 'to make sure we should not be influencing in any degree or manner the judgement of the writer, Millais and I posted a joint letter to thank him for his championship,' wrote Hunt.

The next day John Ruskin and his wife drove to Millais's house, they saw my friend and after a mutually appreciative interview carried him off to their home in Camberwell and induced him to stay with them for a week.

There, Millais's exuberant interest in everything and his youthful impulsiveness in conversation made him 'in a few days like an intimate of many years' duration'.

That was summer 1851. 'I have dined and taken breakfast with Ruskin and we are such good friends that he wishes me to accompany him to Switzerland this summer,' reported Millais. But he was already committed to finding landscape backgrounds in Britain, and it was not until the following year that the friendship was renewed, after Ruskin's father visited the Royal Academy exhibition. On 4 May 1852 he wrote to Millais:

I came home last night with only Ophelia in mind and wrote to my son as nearly as follows. Nothing can be truer to Shakespear [*sic*] than Mr Millais' Ophelia and there is a refinement in the whole figure – in the floating and sustaining dress – such as I never saw before expressed on canvas. In her most lovely countenance there is an Innocence disturbed by Insanity and a sort of Enjoyment strangely blended with lineament of woe.

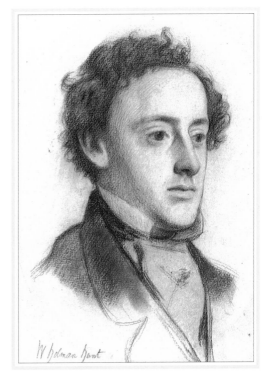

ABOVE: *John Everett Millais by William Holman Hunt, dated 12 April 1853, when the P.R.B. gathered to make portraits of each other to send to Woolner. Fred Stephens started on Millais's 'most splendid head' but was defeated, leaving Hunt to produce this splendid drawing.*

Over the previous winter Ruskin and his wife Effie had been in Venice, where they mixed in high society and Ruskin researched *The Stones of Venice*. They returned home in time to see *Ophelia* and *A Huguenot*, and found Millais already at work on his next picture.

> I have a subject I am mad to commence and yesterday took lodgings at a delightful little inn near a spot exactly suited for its background [he wrote to friends on 9 June]. I hope to begin painting on Tuesday morning and intend working without coming to town at all till it is done.

The subject was *The Proscribed Royalist*, showing a pair of star-crossed lovers at the time of the English Civil War meeting at the bole of an ancient oak tree. The spot was near Bromley in Kent: 'I am waiting here for one more sunny day, to give a finishing touch to the trunk,' Millais wrote in October.

Although unnamed, the figures in the scene probably derived from *I Puritani*, the contemporary Italian opera by Vincenzo Bellini, dramatizing the romance between Elvira and Arturo who belong to the Roundhead and Cavalier factions respectively.

The brilliant satin gown of the fugitive Cavalier's sweetheart was also painted in sunlight, and a pretty professional model named Anne Ryan sat for the figure. The Royalist himself was painted from the artist Arthur Hughes, who recalled:

> I was in the Royal Academy library one evening, looking at books of etchings, and had some by Tiepolo before me, when Millais came in and sat down beside me ... He looked at the Tiepolos and criticised them at once as 'florid, artificial. I hate that kind of thing'. Then he asked me to sit

to him for a head in his picture 'The Proscribed Royalist'. I went and sat five or six times. He painted me in the small back room on the second floor of the Gower Street house, using it instead of the regular studio on the ground floor because he could get sunshine there to fall on his lay figure attired as the Puritan Girl ... When I saw the picture I ventured to remark that I thought the dress of the lady was quite strong enough in colour; but he said it was the fault of the sun; that the dress was rather Quakery but the sunshine on it made it like gold.

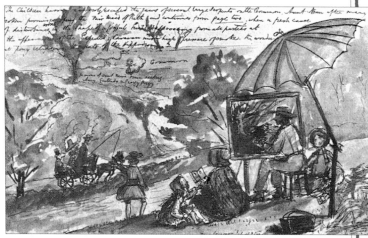

Millais's next subject was *The Order of Release*, set in 1745. Perhaps recalling her Scottish ancestry, he asked Effie Ruskin to sit for the head of the Jacobite heroine, who has secured her husband's release from jail. Apart from the figure's hair, darkened for pictorial purposes, the likeness was a fine one and the expression exquisite, showing 'the subtlest mingling of emotions – shrewdness and triumph and love, mixed with fear of the jailer's power and pride in her own achievement'.

Effie was impressed by the experience of sitting to Millais, as she told her mother:

> He found my head like everyone else who has tried it immensely difficult, and he was greatly delighted last night when he said he had quite got it! He paints so slowly and finely that no man working as he does can paint faster.

Millais had been working excessively hard. 'I have had so little recreation within these last four years,' he told a friend, that 'I shall be ready, directly after my pictures are sent to the Royal Academy, to go with you

ABOVE: *Millais painting out of doors under a sunshade, sketched by his brother William in a family letter. 'I have a subject I am mad to commence and yesterday took lodgings at a delightful little country inn near a spot exactly suited for the background,' wrote the artist when starting work on* The Proscribed Royalist.

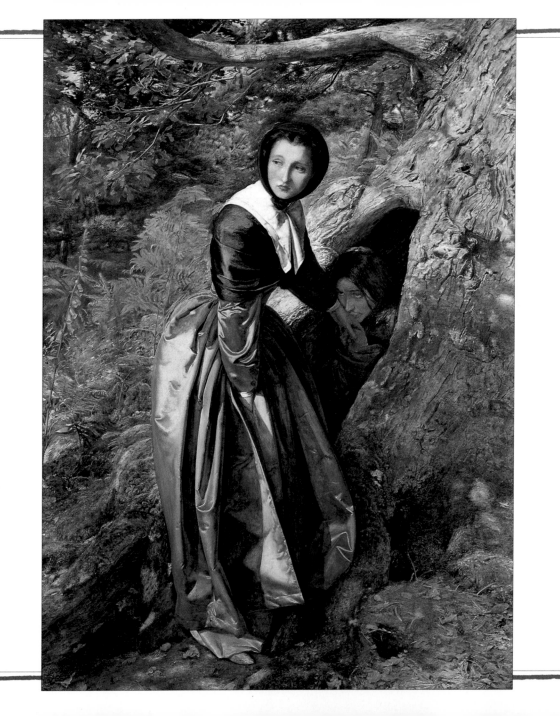

to Norway or the North Pole.' In the event, he accepted Ruskin's invitation to go to Scotland. As Effie wrote to her father:

> It would amuse you to hear the Pre-Raphaelites and John talk. They seem to think that they will have everything for the asking and laugh at me for preparing a great hamper of sherry and tea and sugar.

LEFT: The Proscribed Royalist *(1853) by Millais. Another image of romantic love obstructed by political differences, less provocative than the* Huguenot. *'Roundheads versus Cavaliers' was a popular theme in Victorian art and literature.*

And, she added, Millais was thought so 'extremely handsome, besides his talents, that you may fancy how he is run after'.

After a few days in Northumberland, the holiday group in Glenfinlas, near Brig o'Turk, comprised the Ruskins and the two Millais brothers, John and William, the latter a talented but rather lackadaisical artist.

Millais was commissioned to paint a portrait of Ruskin standing by a waterfall. The place selected for the painting, Ruskin wrote, was:

> a lovely piece of worn rock, with foaming water and weeds and moss, and a noble overhanging bank of dark crag; and I am to be standing looking quietly down the stream, just the sort of thing I used to do for hours together.

ABOVE: *Watercolour study for* The Order of Release *by Millais, set after the Jacobite defeat at Culloden in 1745. 'All the morning I have been drawing a dog, which in unquietness is only to be surpassed by a child,' wrote the artist; 'nothing can exceed the trial of patience they incur.'*

On this working holiday Millais enjoyed himself. 'This day we have been to church,' he wrote one Sunday in August:

> and taken a delightful walk to a waterfall, following the stream till we came to a fall of seventy feet where we had a bath (my brother and self) he standing under the torrent of water, which must have punished his back as severely as a soldier's cat o' nine tails. These mountain rivers afford the most delightful baths, perfectly safe and clear as

51

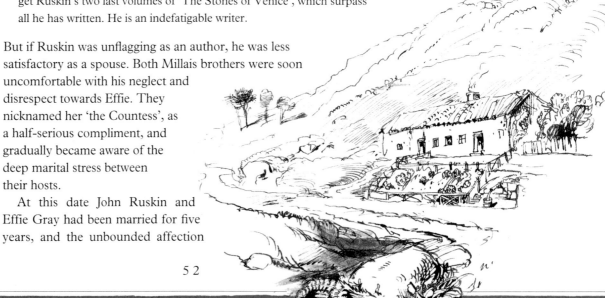

crystal. They are so tempting that it is quite impossible to walk by them without undressing and jumping in ...

We have, in fine weather, immense enjoyment, painting out on the rocks and having our dinner brought to us there, and in the evening climbing up the steep mountains for exercise, Mrs Ruskin accompanying us.

The only drawback was the midges, which bit so dreadfully that it was 'beyond endurance', and painting was often abandoned. But one small canvas shows a typical scene, with Effie sitting by a rocky stream, busy with her needlework, well wrapped against the insects.

When it rained they stayed indoors, playing shuttlecock, or listening to Effie recounting episodes from Scottish history such as Robert the Bruce and the Spider, which Millais mocked mercilessly in sketches. He also read. 'If you have leisure,' he told a friend:

get Ruskin's two last volumes of 'The Stones of Venice', which surpass all he has written. He is an indefatigable writer.

But if Ruskin was unflagging as an author, he was less satisfactory as a spouse. Both Millais brothers were soon uncomfortable with his neglect and disrespect towards Effie. They nicknamed her 'the Countess', as a half-serious compliment, and gradually became aware of the deep marital stress between their hosts.

At this date John Ruskin and Effie Gray had been married for five years, and the unbounded affection

ABOVE: *Crossing the Border into Scotland, 30 June 1853, from a comic sketch by William Millais, showing his brother standing to the left, Sir Walter Trevelyan driving the phaeton and Ruskin (in top hat) leaning out of the carriage behind.*

BELOW: *Ruskin's sketch of the school-master's cottage in Glenfinlas in which he and Effie stayed, from a letter to his father dated 30 September 1853.*

he had expressed during their engagement – 'My own Effie – my kind Effie – my mistress – my friend – my queen – my darling – my only love' – had soured into indifference and complaint.

Ruskin's parents shared his view, accusing Effie of extravagance and neglect of her wifely duties. She in turn began to feel like their prisoner, despised and spied upon. To add to her unhappiness, she was childless, Ruskin having refused all sexual relations. As she explained later to her parents:

> To go back to the day of my marriage the 10th of April 1848. I went as you know away to the Highlands – I had never been told the duties of married persons to each other and knew little or nothing about their relations in the closest union on earth. For days John talked about this relation to me but avowed no intention of making me his Wife. He alleged various reasons, hatred to children, religious motives, a desire to preserve my beauty, and finally this last year told me his true reason (and this to me is as villainous as all the rest) that he had imagined women were quite different to what he saw I was, and that the reason he did not make me his Wife was because he was disgusted with my person the first evening 10th April.

By her 'person' Effie meant her body, and it is assumed that her art-loving husband had never realized real women had pubic hair. When she started to understand more, she cited to him the Bible's endorsement of procreation.

> He then said it would be SINFUL to enter into such a connexion as if I was not very WICKED I was at least insane and the responsibility that I might have children was too great, as I was quite unfit to bring them up. These are some of the facts – you may imagine what I have gone through.

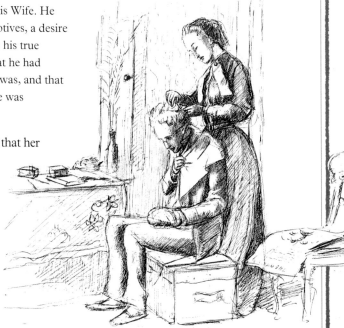

BELOW: 'The Countess as Barber', *Millais's sketch of Effie cutting his hair, dated 25 July 1853. At this date Millais was aged twenty-four and Effie almost exactly a year older.*

Unaware of such details, Millais was nevertheless upset at the way Ruskin treated Effie:

> Why he ever had the audacity of marrying with no better intentions is a mystery to me, I must confess that it appears to me that he cares for nothing beyond his Mother and Father, which makes the insolence of his finding fault with his wife more apparent ... His inquisitorial practice of noting down everything which could forward an excuse for complaining against his wife is the *most unmanly and debased proceeding I ever heard of*, but even that is nothing in comparison with his aggravating unsociability which she has to put up with.

But though Effie's plight had touched his heart, Millais did not wish to divert her affections. The best he hoped for was that:

> I may be beneficial in the end to their position, in regard to each other, as it has disturbed the settled dullness of their existence *and any change was preferable* to the life they have been living (I should rather say the life that she *has been* ENDURING).

When the Highland holiday came to an end, however, Millais and Effie were in love, to all intents and purposes, with no prospect of ever being together. As she explained to her parents:

> For however much he wishes from his regard for me to help me it would be an irreplaceable misery to himself; although he would try not to feel it, it would hurt his independence. His character stands so deservedly high as the founder of a new school and in a great position in this country [that] it would be a lasting sorrow to have that reputation tarnished in the slightest degree. It is a very very important thing for him to keep clear of us altogether and you may tell him not to think it selfish but imperatively necessary ... things may change but he must not hesitate now.

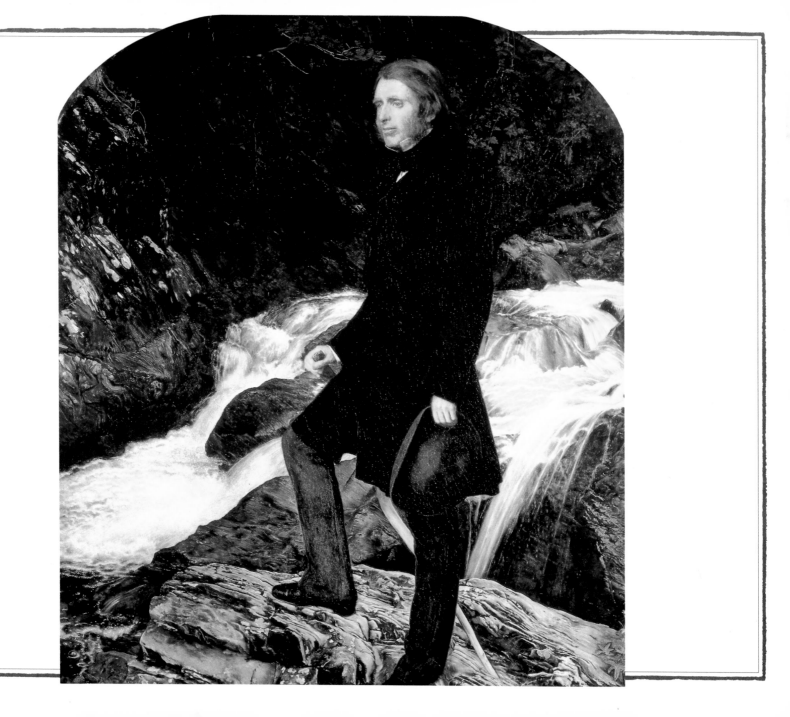

For Millais, the emotional stress was difficult to bear. He wrote to Hunt:

> I should like to sleep for a year and awake and find everything as it was
> when you lived in Cleveland Street when you were straightened for
> food, and we all went nightly to declaim against Rubens and the
> Antique – those were happy times.

Effie's family believed the Ruskins had deliberately thrown her and Millais together in the hope she would disgrace herself and thereby enable Ruskin to seek a legal separation or divorce. Over the winter, in London, her position became more and more difficult. Her young sister came to stay and the Ruskins' hostility mounted. Effie wrote to her parents:

> He has told Sophie that he watches everything I do or say, therefore it
> is impossible I can talk about anything that comes uppermost ... their
> object is to get rid of me, to have John altogether with them again.

They planned, she alleged:

> if possible to disgust me to such a degree as to force me – or else get
> me – into some scrape – John has been trying again to get me by taunts
> to write to Millais. He accepted that St Agnes drawing etc., it now
> hangs before me and then he said 'Didn't I still write to him and where
> was the harm if he gave me drawings' – I said the drawing was as much
> his as mine and to send it back if he liked ... It is impossible for me to
> tell you all until I am obliged to seek my Father's advice.

In fact Effie was seeking other advice and learning that an unconsummated marriage was not legally binding. As Millais hinted to Mrs Gray:

> I am not sufficiently acquainted with Law to know whether something
> more than a separation could be obtained, but I think you should
> inquire into the matter.

ABOVE: St Agnes' Eve *(1854) drawn
by Millais to illustrate Tennyson's
poem about a dying nun:*
Deep on the convent-roof the snows
Are sparkling to the moon:
My breath to heaven like vapour goes
May my soul follow soon!

Somehow Effie managed to communicate with her family without having her letters opened. On 7 March she wrote plainly to her father, detailing her marital history, and asking for his help:

> I have therefore simply to tell you that I do not think I am John
> Ruskin's wife at all – and I entreat you to assist me to get released from
> the unnatural position in which I stand to him.

She added sadly:

> If he had only been kind, I might have lived and died in my maiden state,
> but in addition to this brutality his leaving me on every occasion – his
> threats for the future of a wish to break my spirit – and – only last night
> when I bade him leave me he said he had a good mind to beat me.

'I think he might not oppose my protest,' she concluded; 'in point of fact, could he?'

She was not mistaken. In April Effie left London to travel north with her mother. That afternoon Ruskin received her wedding ring, her house keys and a citation petitioning for the marriage to be annulled on the grounds of impotence.

A few weeks later Effie returned to London for a medical examination that proved she was indeed a virgin, without any 'impediments on her part to a proper consummation of the marriage'. In July 1854 the annulment was granted. Ruskin, as she had suspected, was more relieved than angry; he felt free again, and quickly adopted his parents' view that Effie had been a scheming gold-digger.

Millais had not seen Effie for over six months. He was painting in Derbyshire when he heard 'the best news I have ever received in my life'. He wrote at once:

> I cannot see that there is anything to prevent my writing to you now,
> so I will wait no longer ... for no one has been so keenly interested in

ABOVE: Love, *an illustration by Millais for* The Poets of the Nineteenth Century, *published in 1857.*

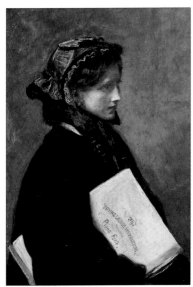

ABOVE: *'I have the greatest reason to be thankful about everything connected with the future as far as I can see,' wrote Effie to a friend in 1855. 'The wedding will be very quiet.'*

the trials you have gone through, or is so happy at this blessed termination ... You may always feel happy in having done your duty, for you have done John Ruskin even a greater service than yourself.

Continuing in a tone almost of disbelief, he wrote:

This time last year there seemed no more chance of what has happened than that the moon should fall, and now you are Miss Gray again. If you could see me, I am sure you would pity me, for I am scarcely able to write common sense I am so bewildered ...

I have been painting out of doors all day, or rather pretending to paint – so that I might be away from my friends, and have some quiet to think upon this wonderful change. I must see you before returning to London, *if you will invite me*. Oh! Countess, how glad I shall be to see you again, this is all I can say now and you must imagine the rest.

But Effie made Millais wait. The emotional stress had already cost him a whole painting season – he exhibited nothing in 1854 – but now he first managed to finish his portrait of Ruskin and then turned his attention to new pictures.

In Derbyshire he painted a small picture of a girl at a stile over a stone wall leading into a sunlit wood, the title of which, *Waiting*, was emblematic of his own state. In London he witnessed firemen fighting a blaze in Tottenham Court Road and began *The Rescue*, showing a fire-fighter bearing children to safety; again, the title seems figuratively apposite to Effie's deliverance. This picture was among the stars of the 1855 exhibition season.

Finally, after a decent interval, Euphemia Gray and Everett (as she preferred to call him) Millais announced their engagement. 'My dear old friend,' he wrote to Hunt on 22 May:

Every week since I wrote to you last I have been saying I will write to Hunt next week. All the hurry and excitement of the R.A. is over and

ABOVE: Waiting, *painted by Millais in 1854. The sunlit wood has been interpreted as symbolic of the future hopes of both the girl and the artist.*

RIGHT: *'A picture full of beauty and without subject' is how Millais described* Autumn Leaves *(1856).*

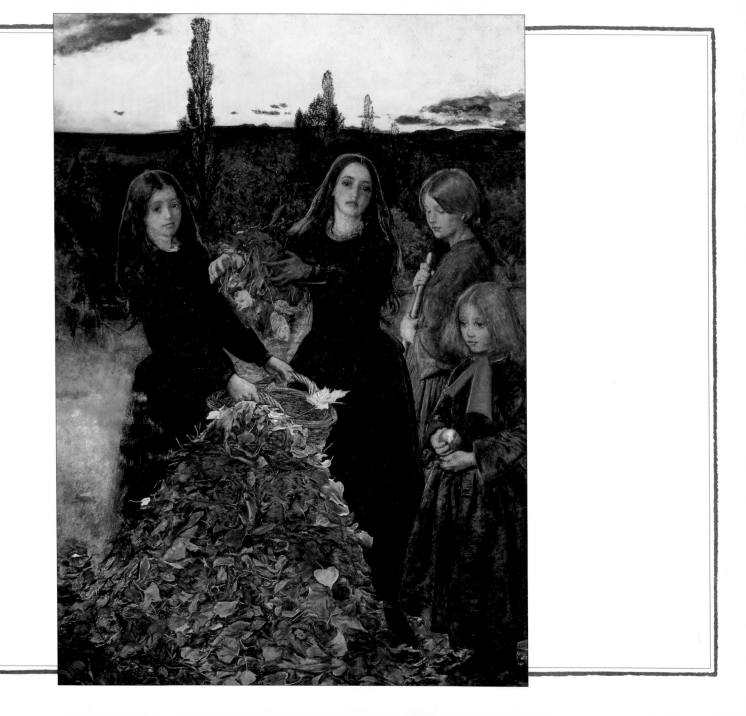

yet I find myself delaying until it is absolutely necessary that I should tell you first that next month please God I shall be a married man ... Since I last wrote I have been in Perth to see her, which was indeed a strange meeting ... She dislikes naturally coming to London after her life in it, and I much fear it will never cease to live in her memory, and will always affect her spirits, but time will show ... Well, it is certainly a strangely tragic tale, and I hope the last scene will be a happy one to her ... I am writing this amidst a crowd of callers ... All London knows now of my marriage and comments upon it as the best thing I could do, the noblest, the vilest, the most impudent, etc, etc, etc.

They were married at the Grays' home in Perth on 3 July and lived happily ever after, eventually raising eight children. During their first weeks together they collaborated on completing Millais's picture of *The Blind Girl*, showing a poor beggar with her sighted sister looking up at a brilliant rainbow, which he had begun the previous year. As Effie wrote in her journal:

RIGHT: Married for Love (1853), one of a series of modern life subjects done by Millais before he got to know Effie. She later made a copy of the drawing, which seems to foreshadow their own marriage.

The background of this picture was painted in the autumn of 1854 in Winchelsea [Sussex], some of the wild flowers and grasses here at Perth and the figures entirely. First of all I sat for the blind girl. It was dreadful suffering, the sun poured in through the window of the study. I had a cloth over my forehead and this was a little relief but several times I was as sick as possible ... [Another] two days I sat in the open air, and when the face was done Everett was not pleased with it and later in the year scratched it out ... The plaid over the head was Papa's, the concertina was lent us by Mr Pringle who had an only daughter who played it.

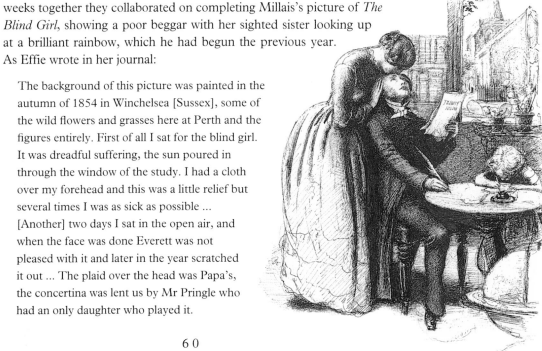

The eventual models for the two sisters were local girls, Matilda Proudfoot and Isabella Nicol.

> Lastly when all the picture was done but little Isabella's feet, which he first began bare but afterwards put on boots, he said an amber coloured petticoat was what he wanted. It was not a week before his going to town [London] and I did not know what I should do. I went down to Bridgend to buy some meat and the first thing I saw was an old woman with the very thing I wanted on. I was in Jean Campbell's, my poultry woman, and said 'You know that woman, Jean. Run and ask her if she would lend me her petticoat.' At night Jean went and she swore an oath and said what could Mrs Millais want with her old coat, it was so dirty, but I was welcome. I kept it two days and sent it her back with a shilling and she was quite pleased.

Millais's other painting begun in 1855 was the beautiful *Autumn Leaves*, also completed in Scotland with Effie's assistance. Her sisters Sophie and Alice sat for two of the girls, Matilda and Isabella for the others. The idea was inspired by a line from the Psalms 'My days are consumed as smoke', and, as Hunt recalled, Millais had often mused on the poignancy of the scene:

> Is there any sensation more delicious than that awakened by the odour of burning leaves? To me nothing brings back sweeter memories of the days that are gone: it is the incense offered by departing summer to the sky, and it brings one a happy conviction that Time puts a peaceful seal on all that has gone.

The last was a sentiment with which Effie would have concurred.

ABOVE: *Comic design (as for a commemorative royal medal) showing Millais and Effie, given to her mother. 'Ever' is a short version of Millais's middle name, which Effie preferred to 'John'.*

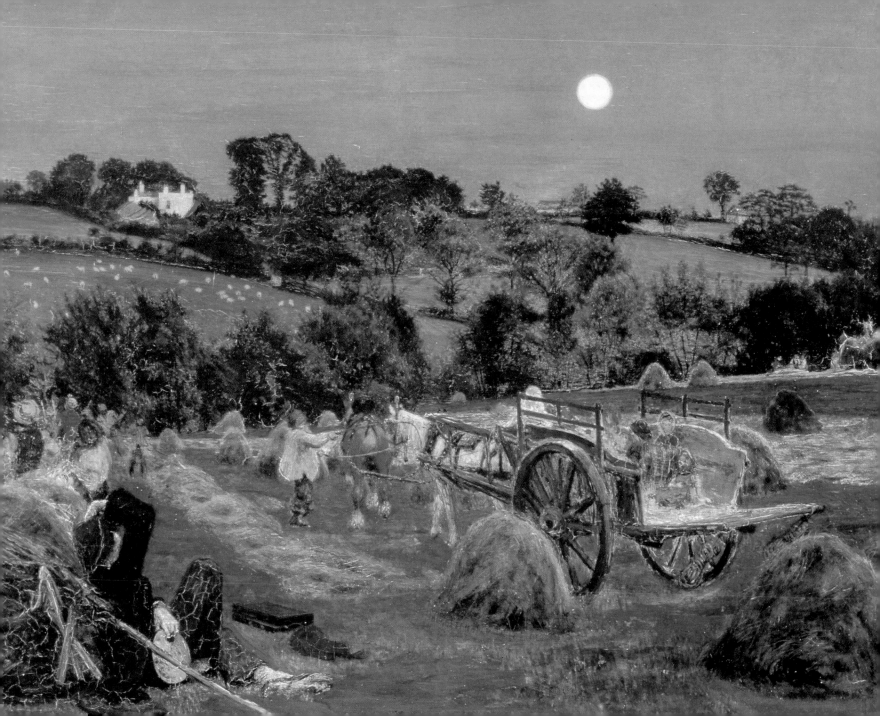

MODERN LIFE
AND LOVE

LEFT: The Hayfield *(1855) by Ford Madox Brown. A twilight scene in the midsummer meadows at Hendon, near where Brown was then living. He himself is seated in the foreground, with palette, paintbox and folded sunshade. In 1856 the picture was purchased by William Morris.*

IN JANUARY 1853 William Rossetti, having neglected for many months to keep his record of events, made what proved to be the penultimate entry in the P.R.B. Journal. He had been to what was to have been a P.R.B. night at Stephens's, but:

> no one attended except myself. Hunt has to take advantage of the moonlight night for his picture of Christ at the door; Gabriel went to Hunt's; and Millais was non-apparent.

William added that he and Gabriel now had an apartment overlooking the Thames near Blackfriars Bridge. And he continued:

> This digression is inapposite just now: for I should not have forgotten to premise that, tho' both Preraphaelism [*sic*] and Brotherhood are as real as ever, and purpose to continue so, the P.R.B. is not, and cannot be so much a matter of social intercourse as it used to be. The P.R.B. meeting is no longer a sacred institution – indeed, is, as such, well-nigh disused; which may explain the quasi-non-attendance at Stephens's. And the solemn code of rules which I find attached to these sheets reads now as almost comic. In fact, it has been a proof of what Carlyle says ... that the formulating of a purpose into speech is destructive to that purpose, for ... the falling-off of that aspect of P.R.Bism dates from just about the time when those regulations were passed in conclave.

Thus the P.R.B. Journal expired. The last concerted effort came some ten weeks later, when Gabriel, William, Hunt and Stephens met

for breakfast in Millais's studio to draw each other's portraits, which they intended to send to Woolner.

The Brotherhood had served its purpose. The members had left the student phase of their lives and were moving in different directions. Collinson had already defected and was now set to relinquish art altogether by joining the Jesuit community at Stonyhurst. Woolner was in Australia, hoping to prosper as a portraitist in the newly rich colony. Hunt was planning to realize a boyhood dream of travelling to paint in Egypt and Palestine. And Millais was hard at work on *The Proscribed Royalist* and *The Order of Release*, the success of which paved the way for his election as Associate member of the hitherto despised Royal Academy later in the year.

Gabriel wrote to tell Christina of this last event, quoting Tennyson's line 'So now the whole Round Table is dissolved'. In response Christina, temporarily domiciled in Somerset with her mother and father, penned the Brotherhood's epitaph in a doggerel ode, which *inter alia* teased her brothers – Gabriel for refusing to exhibit and William for giving up art in favour of journalism:

The P.R.B. is in its decadence: –
For Woolner in Australia cooks his chops;
And Hunt is yearning for the land of Cheops;
D.G. Rossetti shuns the vulgar optic
While William M. Rossetti merely lops
His B.s in English disesteemed as Coptic;
Calm Stephens in the twilight smokes his pipe
But long the dawning of his public day;
And he at last the champion, great Millais
Attaining academic opulence
Winds up his signature with A.R.A.
So rivers merge in the perpetual sea,

BELOW: *Elizabeth Siddal, Hastings, 2 June 1854. One of many exquisite drawings by Rossetti. Brown saw 'a drawerful' of them in Rossetti's studio.*

RIGHT: *Study for the figure of Dante, drawn by Rossetti around 1852. 'I had gone for two or three days to Holman Hunt's lodgings at Chelsea, to sit to him for a head,' recalled William Rossetti. 'My brother at the same time wanted me to sit to him for something else; I think it was the head of Dante.'*

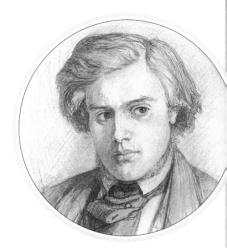

BELOW: *Thomas Woolner, the only sculptor in the P.R.B., drawn by Rossetti in July 1852, shortly before Woolner left for Australia.*

So luscious fruit must fall when over-ripe,
And so the consummated P.R.B.

From the new apartment by the river, Gabriel wrote to Woolner to defend himself:

> There are two Dantesque sketches of mine at a Winter Exhibition in Pall Mall – one which you remember my making at Highgate and another which I hope to paint some day or other, to be called *The Youth of Dante* ... For the introduction of Beatrice ... I quote a passage from the *Vita Nuova*. I have thus all the influences of Dante's youth – Art, Friendship and Love – with a real incident embodying them.

The figure of Beatrice in the watercolour made at Highgate – the first version of *Beatrice Denying Dante her Salutation* – is recognizably that of Elizabeth Siddal, with whom Gabriel was now in love. Something of his feeling is expressed in his translation of a sonnet by Dante on the sudden experience of romance:

> *I felt a spirit of love begin to stir*
> *Within my heart, long time unfelt till then;*
> *And saw Love coming towards me, fair and fain ...*

Only a few friends knew of his secret, however; Gabriel was shy of advertising his affection. On one occasion, he treated Lizzie as a mere model when William Bell Scott arrived without warning:

> I found myself in the romantic dusk ... face to face with Rossetti and a lady I did not recognize and could scarcely see. He did not introduce her; she rose to go. I made a little bow, which she did not acknowledge; and she left. This was Miss Siddal. Why he did not introduce me to her I cannot say.

LEFT: Answering the Emigrant's Letter *(1850) by James Collinson. This scene in a poor household, on the topical issue of emigration which sent so many young Britons to start new lives in Australia, New Zealand and Canada, marks the shift in Collinson's style from traditional to Pre-Raphaelite.*

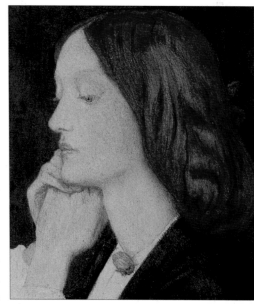

ABOVE: *Elizabeth Siddal (1854), watercolour portrait by Rossetti. 'One face looks out from all his canvases,' wrote Christina Rossetti. 'Fair as the moon and joyful as the light ... Not as she is but as she fills his dream.'*

ABOVE: *Pippa Passes (1854) by*
Elizabeth Siddal. An illustration to
Browning's dramatic poem set in
fourteenth-century Asolo, showing
Pippa's encounter with the 'loose
women' of the streets gossiping about
their clients – an oblique commentary
on Victorian prostitution.

The studio at Blackfriars was partly chosen for its proximity to Lizzie's home across the river. It was also within walking distance of William's office in The Strand, where he worked as a government clerk. And it had other attractions, as Gabriel told Woolner:

> You cannot imagine what delightful rooms these are for a party, regularly built out into the river, and with windows on all sides – also a large balcony over the water, large enough to sit there with a model and paint – a feat which I actually accomplished the other day for several hours in the teeth of the elements.

Perhaps the model was Lizzie. Normally, he referred to her as his 'pupil', for now, under Gabriel's guidance, she was learning to draw as well as sit.

He wanted Madox Brown to come and see her drawings. But Brown was uncharacteristically unsociable. 'Could you come up on Saturday – day time would of course be best, but evening better than not at all,' Rossetti urged vainly on one occasion. And later:

> I would advise you, if you wish to pursue your present solitary habits, to get off Edgar's part in *K. Lear* and when anyone addresses you, answer 'Fe fi fo fum' or 'Pillicock sat on Pillicock's hill', which would perhaps be a quicker method still of cutting off human intercourse.

Moody and depressed, Brown was suffering from poverty and responsibility. His daughter Cathy was now two, and though he maintained her and Emma financially, he could not afford to marry, since this would mean setting up house and supporting Emma's indigent relatives. For a while they lived in south London, where Brown produced his first truly Pre-Raphaelite canvas, painted out of doors in

ABOVE: A Parable of Love *(1850)*
by Rossetti. This is probably his
earliest drawing of Lizzie Siddal and
foreshadows their artistic partnership.

bright sunlight, a startlingly unconventional composition showing a young mother and her child standing tall against the sky:

> My painting room being on a level with the garden, Emma sat for the lady and Kate for the child. The lambs and sheep used to be brought every morning from Clappam [Clapham] common in a truck. One of them eat up all the flowers one morning in the garden.

A gentler composition from this time was *An English Fireside*: Emma sewing by lamplight, with Cathy asleep on her lap.

Brown then moved to a studio in Hampstead, where he began his 'emigration picture', *The Last of England*. It was inspired partly by the topicality of the subject, and partly by his own mood of heaviness and anxiety. He explained:

> It treats of the great emigration movement which attained its culminating point in 1852. The educated are bound to their country by closer ties than the illiterate man, whose chief consideration is food and physical comfort. I have therefore in order to present the parting scene in its fullest tragic development, singled out a couple from the middle classes, high enough through education and refinement to appreciate all they are now giving up, and yet depressed enough in means to have to put up with the discomfort and humiliations incident to a vessel 'all one class'. The husband broods bitterly over blighted hopes and severance from

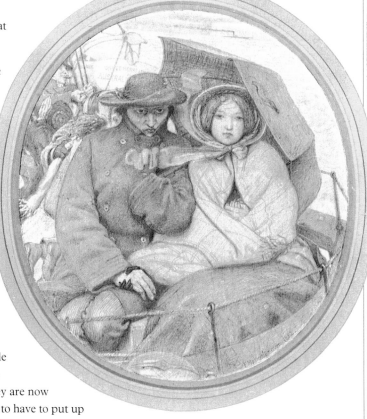

BELOW: *Compositional design for* The Last of England *by Ford Madox Brown.*

all he has been striving for. The young wife's grief is of a less cankerous sort, probably confined to the sorrow of parting with a few friends of her early years. The circle of her love moves with her.

The emotion was reflected in the technique:

the minuteness of detail which would be visible under such conditions of broad daylight, I have thought it necessary to imitate, as bringing the pathos of the subject more home to the beholder.

Having stood in the hot sun with the ill-behaved lambs, Emma now sat in the cold. 'At the beginning of '53 I worked for about six weeks on *The Last England*,' Brown wrote:

Emma coming to sit to me in the most inhuman weather ... I painted at it chiefly out of doors when the snow was lieing on the ground.

Emma's faithfulness was rewarded. In April 1853 they were married. To mark the occasion Gabriel, who was one of the witnesses, drew a candlelit portrait of Emma in ink – a companion piece to his pencil portrait of Brown done six months before.

Later that summer Gabriel left Lizzie alone at Blackfriars, working on a self-portrait. Writing to William about the rent, he added:

I want to tell you Lizzy is painting at Blackfriars while I am away. Do not therefore encourage anyone to go near the place. I have told her to keep the doors locked, and she will probably sleep there sometimes.

On his return, he told Brown that she had made a 'perfect wonder' of her portrait and was now planning a picture from Tennyson. This was probably Lizzie's drawing showing the Lady of Shalott at the moment when the mirror cracks asunder and her fate is sealed:

Out flew the web and floated wide;
The mirror crack'd from side to side;

ABOVE: *Detail from Brown's* The Last of England *(1855) showing the tiny hand of the baby wrapped within the young wife's mantle.*

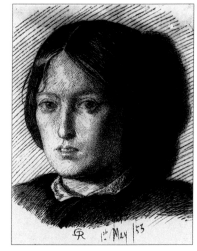

ABOVE: *Rossetti's portrait of Emma Madox Brown, drawn by lamplight on 1 May 1853, shortly after her marriage.*

RIGHT: The Pretty Baa-Lambs *(1852) by Ford Madox Brown. The title is the young mother's words to her somewhat apprehensive child.*

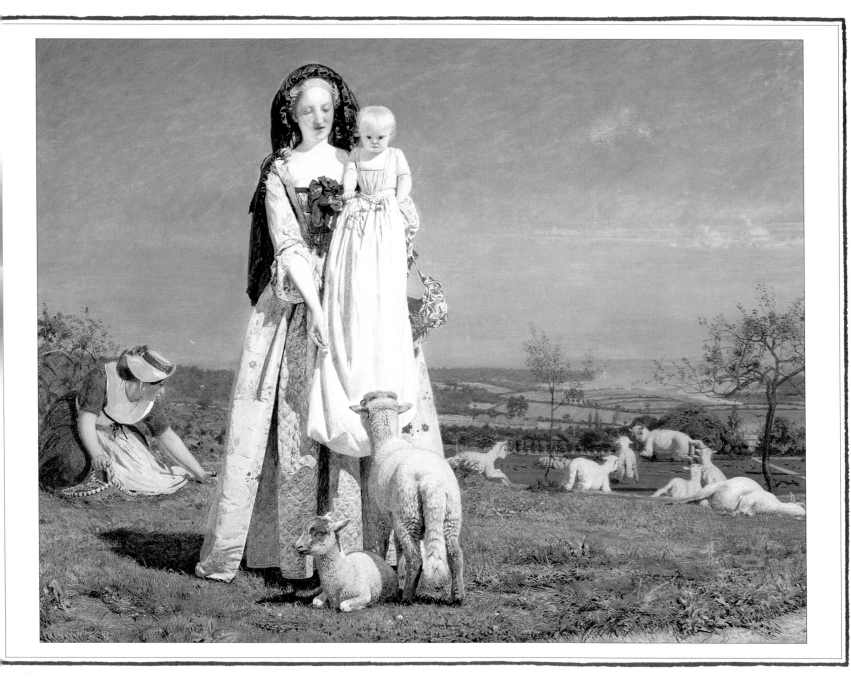

'The curse is come upon me,' cried
The Lady of Shalott.

By attaching herself so unconventionally to the artists' circle, Lizzie had taken a bold step. The second of eight children, she had grown up in London living above the ironmonger's shop owned by her father, a trained cutler originally from Sheffield. While working as a milliner, she developed artistic aspirations of her own that led her to the P.R.B. studios. According to one account, she showed her first drawings to Walter Deverell's father, head of the School of Design, and was then introduced to members of the Brotherhood. They all treated her kindly, but only Rossetti took her dreams seriously. Like Brown, however, he could not afford marriage – as yet.

Lizzie looked delicate, and was often unwell; Gabriel believed that if she could make a positive start in art, 'this more than anything would be likely to have a good effect on her health'. As he wrote:

LEFT: *Another of Rossetti's delicate drawings of Elizabeth Siddal, done at the time of their marriage in 1860, when Lizzie was so ill and weak that it seemed possible she would not be able to get to the church.*

It seems hard to me when I look at her sometimes, working or too ill to work, and think how many without one tithe of her genius or greatness of spirit have granted them abundant health and opportunity ... while perhaps her soul is never to bloom nor her bright hair to fade, but after hardly escaping from degradation and cor-ruption, all she might have been must sink out unprofitably in that dark house where she was born. How truly she may say 'No man cared for my soul'. I fear, too, my writing at all about it must prevent your easily believing it to be, as it is, by far the nearest thing to my heart.

Sept 1853

RIGHT: *Rossetti sitting to Lizzie, September 1853, in a reversal of the usual artist-model relationship. 'Come back dear Liz, and looking wise ... through some fresh drawing scrape a hole', he wrote in 1856.*

He called her his 'dove divine' and drew a bird's head in place of her name in his letters. And as sweethearts will, they adopted interchangeable pet names. She called him 'Gug' – perhaps copied from little Cathy Brown's attempt at 'Gabriel' – while he in response called Lizzie his 'dearest Guggums'. Brown, visiting Chatham Place, saw sheaves of sketches by Gabriel, who was:

drawing wonderful and lovely 'Guggums' one after another, each one a fresh charm, each one stamped with immortality.

Sometimes, in a reversal of roles, Gabriel sat for Lizzie to draw him. His 'instruction' was generally of the gentlest kind. 'Lizzy is sitting by me working at the most poetical of all possible designs, and sends her love to both Emma and you', he wrote to Brown in March 1854.

Meeting Lizzie for the first time that March, Christina drew a poetic portrait of demure devotion:

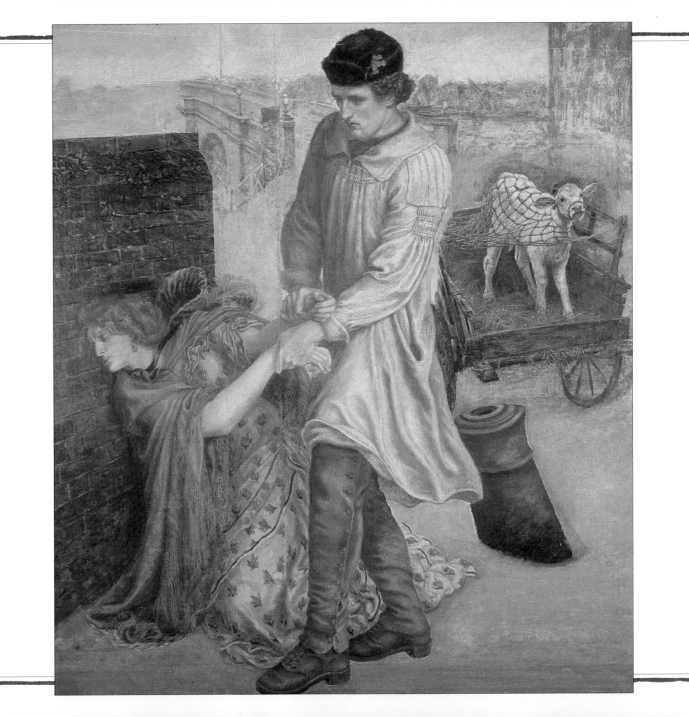

She listened like a cushat dove
That listens to its mate alone;
She listened like a cushat dove
That loves but only one.

And downcast were her dovelike eyes
And downcast was her tender cheek
Her pulses fluttered like a dove
To hear him speak.

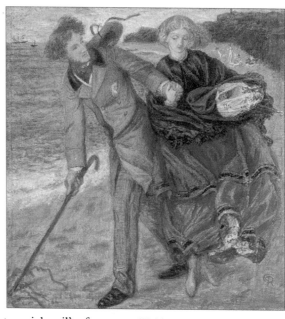

LEFT: Found *(1854, unfinished) by Rossetti. One of the series of 'fallen women' images with which the P.R.B. responded to contemporary concern over prostitution and the lure of the bright city lights. The net holding the calf symbolizes the web of sin in which the woman is caught.*

In May Gabriel and Lizzie were at Hastings. Together they walked on the beach and rambled over the cliffs. Gabriel drew Lizzie's profile in the sand and carved their initials on the rocks. Other days they sat in the lodging house reading and drawing.

At the Royal Academy in 1854 Hunt exhibited *The Awakening Conscience*, intended as a secular and modern-life counterpart to *The Light of the World*. Its theme – that of remorse for loose sexual morals – chimed with contemporary concern over the 'great social evil' of prostitution. Lizzie also made a drawing on this topic, illustrating an incident in Browning's dramatic poem 'Pippa Passes'; and Gabriel was inspired to tackle a subject he had long planned, showing a streetwalker discovered at dawn by her former sweetheart, a young countryman bringing a calf to market, entitled *Found*.

Having sketched out his composition, Gabriel spent some weeks painting a picturesque wall, brick by brick, and then invited himself to stay with the Browns, now living in Finchley, in order to paint a calf belonging to a neighbouring farmer.

Brown himself was working on local landscapes and *The Last of England*. His painting diary that autumn records events as they unfolded, including news from the battlefields of the Crimea:

ABOVE: Writing on the Sand *(1859) by Rossetti. Though the background is not Hastings, this watercolour seems to refer to the artist and his beloved walking on the beach in windy weather. With his stick the man is drawing the woman's profile.*

ABOVE: *Rossetti's self-portrait, dated 20 September 1855. 'On Sunday I called on the Brownings, as I want to give Lizzy an introduction to them if she goes to Florence,' he wrote to Brown a day earlier. 'He's coming to see me, and I have borrowed Lizzy's Pippa Passes to show him.'*

5TH OCTOBER.

Took Lucy back to school calling on the Rossettis in the way. They well, no cholera in Camden Town. Gabriel supposed to be at work at Blackfriars & William returned from Cornwall & Ostend. Heard from Christina the first news of the fall of Sebastopol – What times we live in.

6TH OCTOBER

Up late shower bath off to the field, rain, wasted about an hour and half under an umbrella at the sweeds [swedes, for *Carrying Corn*].

6TH NOVEMBER

Worked at Emma's head in 'the Last of England' (5 hours).

8TH NOVEMBER

Worked at my own head in the same – had a baby to put in the infant's hand, made a mess of it – worked at the head again till dark & all the evening from feeling – Gabriel d[itt]o at his calves head (10 hours).

Fond as he was of Rossetti, the strain began to tell. On 2 December Brown wrote:

today no work. Woolner dined here last night. I walked out with Emma and then over to Hendon to arrange with Smart our grocer about not paying him & getting credit ... Saw Gabriel's calf, very beautiful but takes a long time. Endless emendations for no perceptebel [*sic*] progress from day to day & all the time he wearing my great coat which I want & a pair of my breeches, besides food & an unlimited supply of turpentine.

On 4 December he returned home to discover that Gabriel had been frightening Cathy by saying he 'would *put her in the fire*':

Begins to us, on our entering, with 'That ass of a child' – I stop him with 'I've told you before I don't choose you to call my child an ass, it

is not gentlemanly to come & abuse a persons children to them – if you can't stay here without calling her names you had better go'. He did *not go*, but was silent for the rest of the evening.

Gabriel finally left just before Christmas, promising to return. 'My dear Brown,' he wrote:

> Will you oblige me by sending the carrier for my case and paintbox and easel, with the note which I enclose, and give them houseroom until I know whether I had best have them up to town or not, before I return again for a day to Finchley ... I suppose a day more will be necessary, as I ought to do the back and wheel of the cart and pony's legs and ears.

LEFT: Study of his son Arthur, by Ford Madox Brown, done in the winter of 1856–7. Arthur was born in September 1856 and died suddenly the following July. This drawing was made for a painting called Take your Son, Sir!, *which was abandoned unfinished after Arthur's death.*

But the painting was laid aside, and Gabriel did not return to Finchley. In January 1855 Emma gave birth to her second child, a boy named Oliver. And around this time Brown's fortunes began to improve. By the autumn the family was installed in a new house closer to the centre of London. 'I have been thriving rather more of late,' he told Hunt, 'and am now living in a large house instead of (as you used to say) an outhouse.'

Ruskin had diverted his patronage from Millais to Rossetti. Part of his motivation was philanthropic as he explained:

> I forgot to say also that I really do covet your drawings as much as I covet Turner's; only it is useless self-indulgence to buy Turner's [who had died in 1851] and useful self-indulgence to buy yours.

According to Rossetti, his new benefactor:

> the other day wrote me an incredible letter, remaining mine respect-fully (! !) and wanting to call ... his manner was more agreeable than I had always expected [and] he seems in a mood to make my fortune.

77

Ruskin then asked Gabriel for first refusal on all his work, and often paid in advance. As William remarked:

> I cannot imagine any arrangement more convenient to my brother, who thus secured a safe market for his performances, and could even rely on not being teazed to do on the nail work for which he received payment ... In this respect Ruskin appears to have been always friendly and accommodating, and Rossetti not unduly troublesome.

ABOVE: *View of St Paul's Cathedral from Blackfriars Bridge around 1850. The building on the left, standing at the north-east end of the bridge, was matched by another on the north-west (since demolished), where Rossetti's studio at 14 Chatham Place was located, overlooking the river.*

They developed a bantering relationship. Ruskin 'praised freely, and abused heartily' in a manner that was meant and taken with good-humour, but sometimes nettled Gabriel, who was 'at bottom scornful of art-critics'. Although grateful for Ruskin's money and approval – especially his commendation to other art-buyers – Rossetti did not want to be influenced by Ruskin's opinions, which were often forcefully expressed:

> Take all the pure green out of the flesh in the *Nativity* I send, and try to get it a little less like worsted-work by Wednesday ... It's *all your own pride* not a bit of fine feeling, so don't think it. If you wanted to oblige *me* you would keep your room in order and go to bed at night ... I was put out today, as you must have seen, for I can't hide it when I am vexed. I don't at all like my picture now ... [However] the *Magdalene* is magnificent to my mind in every possible way; it stays by me.

He extended his courtesy to Lizzie, writing to Gabriel:

> I forgot to say to you when I saw you that, if you think there is anything in which I can be of any use to Miss Siddal, you have only to

RIGHT: *Heath Street, Hampstead, 1855. An oil study for Ford Madox Brown's painting* Work, *this shows the upper roadway known as The Mount, with Heath Street to the right.*

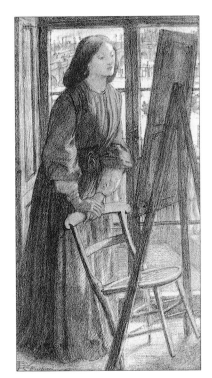

tell me. I mean, she might be able, and like, as the weather comes finer, to come out here sometimes to take a walk in the garden and feel the quiet fresh air, and look at a missal or two ... And, if you think she would like an Albert Dürer or a photograph for her own room, merely tell me, and I will get them for her. And I want to talk to you about her, because you seem to me to let her wear herself out with fancies, and she really ought to be made to draw in a dull way sometimes from dull things.

Gabriel did not agree. He was drawing imaginative scenes from Dante, from Scripture and from Tennyson's poems; Lizzie was doing the same, substituting Border Ballads for *The Divine Comedy*.

In spring 1855 Gabriel and Lizzie were invited to tea with Ruskin and his parents. 'All were most delighted with Guggum', he told Brown excitedly. 'JR said she was a noble, glorious creature, and his father said that by her look and manner she might have been born a countess.' The next day Ruskin called at Chatham Place:

to propose two plans for her: – one, that he should take whatever she did henceforward and pay for them one by one: the other, that he should settle on her £150 a year forthwith, and that then she should send him all she did – he to sell them at a higher price (if possible) to her advantage, and if not, to keep them himself at the above yearly rate. I think myself the second plan best, consider-ing that there may be goodish intervals when she cannot work and might run short of money: but she ... does not seem to like so much obligation and inclines to the first plan.

Gabriel was in celebratory mood, as he told Brown:

Meanwhile I love him and her and everybody, and feel happier than I have felt for a long while ... Lizzy is to take tea, perhaps dinner, at my mother's tomorrow, and is to come

ABOVE: Elizabeth Siddal in front of the easel at 14 Chatham Place, drawn by Rossetti. The tall windows behind opened on to a small balcony. Blackfriars Bridge is lightly sketched in the background.

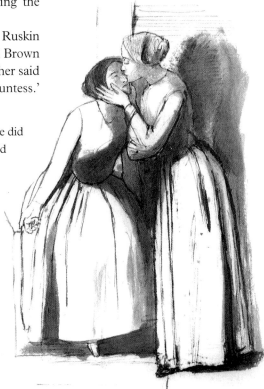

BELOW: Study for the 'Ballad of Fair Annie', done around 1855 by Rossetti for a projected anthology of ballads he and Lizzie planned to illustrate.

here as early as she can ... Could you and Emma come here and accompany us?

This mood perhaps inspired some lines in one of Lizzie's poems:

> Love kept my heart in a song of joy,
> My pulses quivered to the tune;
> The coldest blasts of winter blew
> Upon me like sweet airs in June.
>
> Love floated on the mists of morn
> And rested on the sunset's rays;
> He calmed the thunder of the storm
> And lighted all my ways.

Tactfully, Ruskin enquired whether Gabriel had 'any plans or wishes regarding Miss S., which you are prevented from carrying out by want of a certain income, and if so, what certain income would enable you to carry them out?' His own view was that:

> it would be best for you to marry, for the sake of giving Miss Siddal complete protection and care, and putting an end to the peculiar sadness and want of you hardly know what, that there is in both of you.

He was perceptive, for something stood between them and marriage which Brown did not understand. 'Rossetti once told me that, when he first saw her, he felt his destiny was defined,' he wrote in his diary. 'Why does he not marry her?'

Instead, at Ruskin's urging, Lizzie went away, first to Oxford and then to the resort of Clevedon in Somerset, where, she reported:

> the donkey-boy opened a conversation by asking if there was any lions in the parts she comed from. Hearing *no*, he seemed disappointed, and asked her if she had ever ridden on an elephant there ... He wished to

ABOVE: St Cecilia *wood-engraving designed by Rossetti for the Moxon edition of Tennyson's* Poems *(1857), showing an angel gazing into the eyes of the patron saint of music.*

ABOVE: Mariana in the South, *Rossetti's design for the Moxon Tennyson. In the poem, forlorn Mariana prays before an image of Our Lady, not (as here) Christ.*

know whether boys had to work for a living there, and said that a gentleman had told him that in his country the boys were so wicked that they had to be shut up in large prisons ... All that could be got in an explanation of why he thought Lizzie some outlandish native was that he was sure she comed from very far, much farther than he could see.

In the winter Lizzie went to the south of France, for the sake of her health. Gabriel joined her in Paris, and then returned to London. On 15 February 1856 he wrote a funny-sad poem containing the verses:

ABOVE: The Merciless Lady *(1865)*
by Rossetti, showing a man between
two women, one dark, one fair, in
triangular tension of the kind that
characterized many of his own
emotional relationships.

Yesterday was St Valentine.
Thought you at all, dear dove divine,
Upon that beard in sorry trim
And rueful countenance of him,
That Orson who's your Valentine?

He daubed, you know, as usual.
The stick would slip, the brush would fall:
Yet daubed he till the lamplighter
Set those two seedy flames astir;
But growled all day at slow St Paul.

Some time over the fire he sat,
So lonely that he missed his cat;
Then wildly rushed to dine on tick –
Nine minutes swearing for his stick,
And thirteen minutes for his hat.

Come back, dear Liz, and, looking wise
In that arm-chair which suits your size,
Through some fresh drawing scrape a hole.
Your Valentine and Orson's soul
Is sad for those two friendly eyes.

RIGHT: Paolo and Francesca *(1855)*
triptych illustrating Dante's Inferno
done by Rossetti for Ruskin. The illicit
lovers, their passion roused by reading
of the adulterous love between Lancelot
and Guenevere, are condemned to
toss forever amid the flames of hell.
In the centre Dante and Virgil lament
their cruel doom.

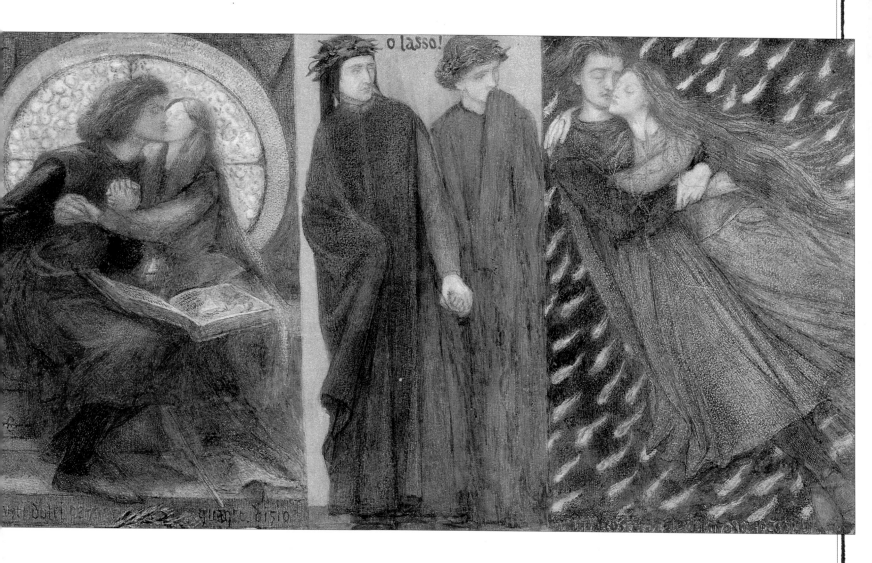

Ruskin's patronage freed Rossetti from the need to exhibit. In April William wrote to update Scott:

> You insinuate a sarcasm against Gabriel's indolence. It is undeserved. Since Ruskin, now about 2 years ago, began commissioning and buying his watercolours, he has been doing works of that class with really exemplary perseverance, and not without tangible result, though he still abstains from exhibiting. I think Ruskin must possess something like a score of his things by this time – some of which I myself have not seen.

He went on to itemize:

> Those which I have seen include *Paolo and Francesca* in three compartments – the kissing business on one side, the tormented souls on the other, and midway Dante and Virgil; [also] Queen Guenevere refusing her lover Lancelot a kiss when they meet over the grave of Arthur; Beatrice refusing Dante her salute at a marriage feast (a duplicate of one done some years ago, but carried a good deal further); one of the Kings and one of the shepherds led together by an angel to worship at the Nativity; a medieval woman holding a man's arm and singing (which Ruskin likes about the best of all).

Although the Brotherhood were drifting apart, their careers were prospering. 'The R.A. Ex is full of P.R. work this year,' boasted Gabriel in May. For now, after seven years, the style had surmounted most of the hostility – from the public, if not from the press. Millais in particular filled the leading position by virtue of popular acclaim, though his erstwhile Brethren were judicious in their appreciation of his current endeavours, now he was painting to support a wife and family.

ABOVE: *Portrait medallion of Tennyson by Thomas Woolner (1856), engraved as frontispiece to the Moxon edition. Having returned from Australia at the end of 1854, Woolner resumed his career as sculptor and produced this image of the Poet Laureate.*

Of *Peace Concluded*, William wrote:

> an Officer back from the Crimea, with his wife (Mrs Ruskin-Millais)
> on the sofa, reading the *Times* news of the peace, and his two little
> girls, one of whom, playing with a Noah's Ark, has produced the lion,
> Russian bear, cock and turkey [national symbols of the four combatant
> nations] and finally brings out the dove with the olive-branch. 'Rather
> puerile,' I fancy you saying.

But the picture had sold for '£900 (!) ... so you see Millais has
not lost the art of success'. However:

RIGHT: *Robert Browning by Francis Talfourd (1859). 'Confronted with Browning's verse, all else seemed pale and in neutral tint,' recalled William Rossetti. 'Here were passion, observation, aspiration, medievalism, the dramatic perception of character, act and incident.'*

> it is undoubtedly true that Millais is confirming himself in
> the tendency to paint with greater breadth, and more for
> distant effect; but, if he keeps up to the standard of
> *Autumn Leaves* I conceive this still to be
> Preraphaelitism, and perfectly legitimate. It is to be
> hoped he will not lose himself in obvious, popular, or
> frivolous subjects; but I think the want of Hunt's com-
> panionship may be felt on this point.

Eventually, William's prediction proved true. Having bat-
tled for some years in the face of what he felt was carping
criticism, and though still capable of Pre-Raphaelite poetry
and precision in his work, Millais increasingly tended towards
more obvious and commercial subjects. 'Whatever I do, no matter
how successful,' he complained, 'it will always be the same story:
"Why don't you give us the Huguenot again?" ' The Victorian appetite
for sentiment was insatiable.

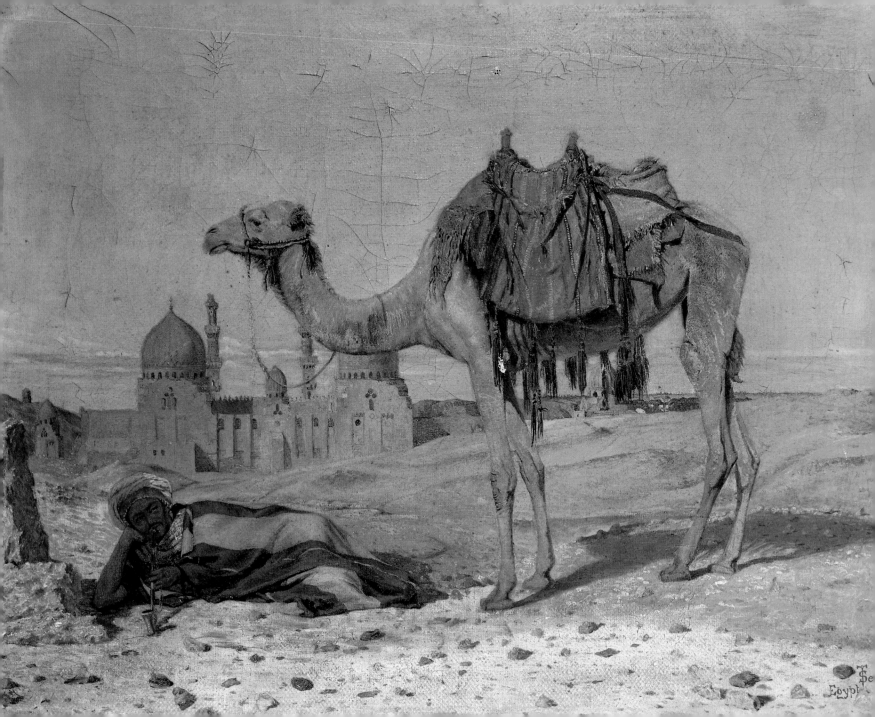

HUNT IN THE HOLY LAND

HOLMAN HUNT WAS NOT AVAILABLE to advise Millais on subjects because since early 1854 he had been travelling in the Middle East. This was despite war in the Crimea and discouragement from his friends. 'Will you still persist in going to the East?' Millais had written plaintively:

> If so, I am sure you will be cut up and eaten by the Russians ... I wish you would not forget your original promise that you would write for me to meet you at Cairo after the first year. I don't think I could live in London somehow when you are gone.

He gave Hunt a signet ring in token of their friendship, which Hunt wore to the end of his life. From Rossetti Hunt received a photograph of *The Girlhood of Mary Virgin*, and a quotation beginning:

> *There's that betwixt us been, which men remember*
> *Till they forget themselves, till all's forgot ...*

'I took a cab and made a round of calls on my friends to say good-bye,' recalled Hunt:

> dear old Millais was astonished when I said I was going away that night by the mail train. John came back with me and helped me to pack. Some bachelor friends rallied me, saying that they should go and dine leisurely and come on to my lodgings later. When they arrived I had gone, and Millais had accompanied me to the station. I had not had

ABOVE: *Self-portrait of William Holman Hunt in Arab dress. Hunt maintained a strong British identity while in the Middle East but on his return home enjoyed wearing and being seen in Arab costume.*

time to dine, and Millais rushed to the buffet and seized any likely food he could, tossing it after me into the moving carriage. What a leave-taking it was with him in my heart when the train started! Did other men have such a sacred friendship as that we had formed?

Travelling via Paris, Marseilles and Malta, Hunt arrived in Cairo in February. He was not impressed by Egypt – or perhaps disguised his true impressions behind the disdain of a nervous traveller:

The Pyramids themselves are extremely ugly blocks, arranged with imposing but unpicturesque taste. Being so close at hand, it is difficult to refuse making a sketch of them ... Their only association that I value is that Joseph, Moses and Jesus [*sic*] must have looked upon them. There are palm trees which attract my passing admiration.

ABOVE: *Painting in the East, sketch by Holman Hunt in Cairo, 1854. 'The interior of the bazaars, the streets, the mosques, the fountains, the tombs of the caliphs, the view from the citadel, the gates, old Cairo, all in turn offered a perfect subject for a painter,' he wrote.*

He met up with a friend and fellow artist, Thomas Seddon, but took some time to settle down to work, complaining both of the continual braying of donkeys – the pack-animals of Cairo – and of his fellow tourists. He told Millais:

I find a good deal of difficulty in living in quiet here, for there are four or five other Englishmen in the hotel, some of them very pleasant fellows, but I want solitude for my work, and it is impossible to feel secluded enough even when Seddon is away. When he is present, serious devotion to thought is often shattered by intolerable and exasperating practical jokes .

Together they made an excursion to the Sphinx, taking a tent and two camels, drivers and a cook. One night there was a windstorm. 'You would have laughed to have seen Hunt and myself rushing out in our

ABOVE: *Inside a Pyramid, sketch by Holman Hunt in a letter to Millais, 8 May 1854. 'I held the hand of Abdullah in front and of the other behind, in established order, and in spite of a liberal heat and perspiration suffered by each, we progressed at quick measure.'*

night attire,' reported Seddon, 'he looking grave and holding on like grim death to the skirts near him, while I was roaring with laughter and holding on to the ropes outside.'

Naively, Hunt was surprised to find it harder to obtain models in Cairo than in London – owing not only to the lack of any such artistic tradition but also to the Islamic ban both on depicting likenesses and on unveiling women. 'Poor Hunt is half bothered out of his life here in painting figures,' Seddon told Brown:

> but, between ourselves, I think he is rather *exigeant* in expecting Arabs and Turks in this climate to sit still (standing) for six or eight hours. Don't tell anyone this, not even Rossetti.

Hunt himself wrote impatiently to Millais:

> Bedouins may be hired in twenties and thirties, merely by paying them a little more than their usually low rate of wages, and these are undoubtedly the finest men in the place; but when one requires the men of the city, or the women, the patience of an omnibus-man going up Piccadilly with two jibbing horses on an Exhibition-day is required.

He recounted an unsuccessful attempt to procure female models, which ended in violent confusion, and continued:

> The next day I applied to the wife of the English missionary, who replied that it was a matter of the greatest difficulty. She had once induced a girl to sit, but then it was to a clergyman. Perhaps it might be possible to get her again for me, but not at present, for it was a great fast [Ramadan] which was observed at home indoors and moreover she herself was just setting out for Mount Sinai for two or three months.

BELOW: *On 11 May Hunt and Seddon travelled down the Nile from Cairo to Sammanud, where Hunt sketched this group of young men playing siga. The river and furled sail of a felucca are visible in the background.*

ABOVE: *A 'gentle-minded buffalo suckling her calf' was stabled near Hunt's hotel in Cairo, alongside a constantly braying donkey. Hunt described her as 'a perfect type of English art, harried, hindered and driven to despair by blatant criticism.'*

89

But Hunt was not to be deterred, certain he could get models:

> There are beautiful women here. In the country the fellah girls wear no veils and but very little dress, and these in their prime are perhaps the most graceful creatures you could see anywhere. In prowling about the village one day I came face to face with one of them and could not but stop and stare at her.

One such woman provided the figure in *The Afterglow in Egypt*, begun at Giza 'in an open cave under the plateau of the Pyramids'. This image was, Hunt wrote later, intended to suggest that 'although the meridian glory of ancient Egypt has passed away, there is still a poetic reflection of this in the aspect of life':

> It was the one illumination which I found to suit the subject in Nature – the strong second glow which comes in the East when the sun has sunk a few minutes.

Among the other artist-travellers in Cairo was the comic writer and serious landscapist Edward Lear, an old friend. In April, however, Hunt and Seddon left Egypt earlier than they intended. As Seddon reported:

> You will, perhaps, be surprised to hear that our plans are changed, but the fact is, that Hunt discovered, two or three weeks ago, that when Jacob left his father's house he was a middle-aged man of forty, which stopped him from painting a picture of him in the wilderness, as he had intended to have done at Sinai; so, not being a landscape painter, he thought he could not spend a whole summer there ... so we start in a few days for Damietta ... and thence by ship to Jaffa and Jerusalem.

They rode from Jaffa towards Jerusalem through the mountains of Judaea:

There were no sort of roads then, and no cafés of any kind, but we rested ourselves under a sycamore tree, where we got water and ate our dried fruit with the bread which we had brought ... Little clusters of trees stood on the surface of the slopes, where the spot was protected by villages and the plantation straggling out along the terraces behind the projecting crags proved the presence of a fellahin settlement, otherwise the slopes were garnished with nothing but broom and underwood ... The descent to the valley was by straggling tracks with frequent steps and turns to be made, apparent only as we approached, and at the bottom there was a drink of water for ourselves and our beasts; but after a pause at the well, an exchange of news with muleteers coming in opposite directions, we started again with eagerness to reach the goal of pilgrimage sacred to Jew, Christian and Mohammedan.

Nor were they disappointed with their first sight of Jerusalem:

We climbed up with sight alone bent on the horses' path. Suddenly and unbidden our beasts stopped, we raised our eyes and there all the scene had opened, a great landscape was spread before us, and in the centre stood our city. Foursquare it was and compact in itself ... The inner side of [the] wall was apparent in places between nearer buildings; the domes and minarets rose against a range with swelling outlines forming the Mount of Olives and Hill of Offence, and where the line of the northern mass sloped down and left a gap between itself and a southern continu- ation ... appeared a far distant horizontal range of mountains of amethyst and azure hue, the Mountains of Moab.

BELOW: *Holman Hunt among Jews at a synagogue in Jerusalem, from a sketch. 'Every Saturday and on all grand days I went to the synagogues and watched the ceremonies,' he wrote. 'I was noticed myself and asked questions as to my nationality, my object and eventually to what synagogue I belonged.'*

Seddon's aim was to paint landscape –
the veritable landscape of the Bible.
Hunt's plan was to paint a picture of
Mary finding Jesus as a child disputing
with the rabbis in the Temple. From
the Talmud, he tried to learn what
conditions prevailed in Christ's time;
he visited synagogues to observe the
ceremonies; and he pursued models,
hindered by current controversy over
Christian proselytism in the city, which
made Jewish residents reluctant to have

*ABOVE: 'Halt at a Well' from a sketch
by Holman Hunt. 'We were approached
by some Jehalin Arabs who, having
heard of our intended journey, had
come to guide us to their encampment.
We halted on the way at a well, reached
our Bedouin tents near sundown.'*

dealings with British visitors, and also by unshakeable decorum.
Introduced to one of 'the most important Jewish families' in Jerusalem,
Hunt wanted to paint the grandmother, mother and daughter – 'all sin-
gularly beautiful'. The British missionary doctor undertook to ask,
believing that they would pose in gratitude for his services. But he
underestimated the strength of their resistance; they were 'polite in all
but compliance.'

Palestine, though an utterly foreign land in most respects, was famil-
iar from Scripture, as Hunt wrote to Millais, in words that also reveal
his homesickness:

It may be interesting to you to know that my tent was pitched on the
plain of Mamre, under a tree still called 'Abraham's Tree', where he
entertained three angels ... Here I laid [*sic*] down in the middle of the
day, and took out your letters ... and re-read them again with a delight
which made every word like pure water to a thirsty soul. I could
remember Winchelsea so clearly, all our walks there together, and our
meal at the inn ... And how I could have joyed to be with you, to talk
together for a few hours!

BELOW: *Detail of the Christ Child's face, from* The Finding of the Saviour. *The model was Cyril Flower, said to be the original of* Eric, *or* Little by Little, *who later built up a collection of Pre-Raphaelite paintings.*

RIGHT: The Finding of the Saviour in the Temple *(1854–60) by Holman Hunt. Exhibited with an inscription in Latin and Hebrew from the Book of Malachi: 'And the Lord, whom ye seek, shall suddenly come into his temple.'*

Hunt had a new idea for a painting, as he explained in another letter that was passed round among his friends in London:

> For the next week or two I shall be stationed about sixty miles from Jerusalem and with no means of despatching letters thence or communicating with any human being above a wild Arab. The prospect is sufficiently dreary to say the least of it, but I am tempted to it for the sake of a serious subject that has come into my head, for the next exhibition of the Academy ... In Leviticus xvi:20 you will read an account of the scapegoat sent away into the wilderness, bearing all the sins of the children of Israel, which, of course, was instituted as a type of Christ. My notion is to represent this accursed animal with the mark of the priest's hands on his head and a scarlet ribbon which was tied to him, escaped in horror and alarm to the plain of the Dead Sea, and in a death-thirst turning away from the bitterness of this sea of sin.

This would be interesting topographically as well as spiritually and, he added, might also be an aid to conversion.

> My last journey was to discover an appropriate place for the scene, and this I found only at the southern extremity of the lake where the beach is thickly encrusted with salt, and notwithstanding a remarkable beauty, there is an air of desolation ... Usdoom is a name applied to a mountain standing in the plain, which from the resemblance in sound is thought to be part of Sodom. Its greater part is pure salt, which drips through into long pendants whenever the water descends.

To combat the terror of making such a journey into lands inhabited only by semi-nomadic tribes, Hunt kept a journal:

17 NOVEMBER
Never was so extraordinary a scene of beautifully arranged wilderness ... I commended myself to God's merciful protection from all the

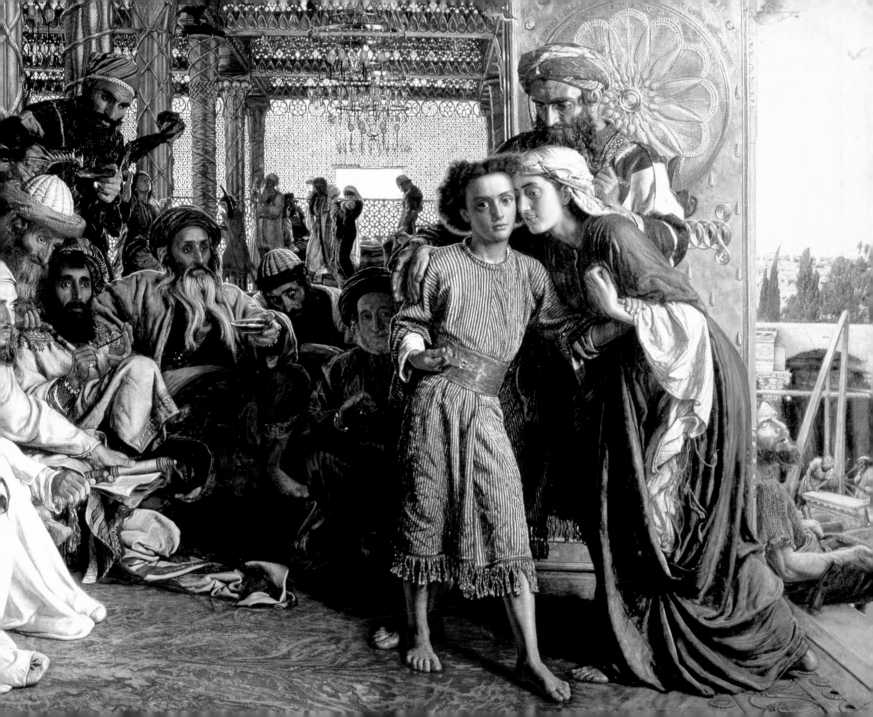

dangers by which I had ventured to challenge in this pursuit – I believe if I had not had the comfortable assurance of his presence and defence of me – that I should have been overcome and cried like a child at the misery of my solitary position – as I reached this place and alighted for the shade.

19 NOVEMBER

We see footprints of beasts but I think none of them inhabit the place. The Vulture never comes there to make his feast altho' he might gorge him self to the full on the camels corrupting in the sun ... the mountains lie afar, beautiful as precious stones but anear they are dry and scorched, the rose colour is the burnt ashes of the grate. The golden plain is the salt and naked sand. The Sea is heaven's own blue, like a diamond.

The difficulties of painting on site were revealed when his canvas became covered in dust, despite being transported on mule-back in a box. In addition, the light kept changing:

21 NOVEMBER

Worked all day at the sea to the left, and the upper part of the beach adjoining, in which I progressed well, but not so satisfactorily as I might have done in remaining another half hour when the effect came right.

His moods fluctuated as his time for leaving the Dead Sea approached:

23 NOVEMBER

I am tired out and brought to submit to a great disappointment - the loss of my object - for in two days I can scarcely do enough of the intricate foreground ... so I fear all

BELOW: Head of Bearded Vulture shot by Holman Hunt near the Dead Sea in 1854.

my past work is lost, this which I undertook so sanguinely and have encountered so many difficulties to succeed in, that I might have a picture of some value in the next exhibition!

25 NOVEMBER

I went down early this morning and I laboured ceaselessly till sunset not having a soul passing to trouble me except my guard Soleiman ... in ten or fifteen minutes of sunset I managed to do a large piece of the lower foreground on the left, and this encourages me for tomorrow, for I feel that I have succeeded in the color and tone excellently. I spent an hour in shading and lightly modelling the mountains.

Back in Jerusalem Hunt painted a goat procured by 'two venturesome lads', which he stood on a tray covered with mud and salt brought back from the Dead Sea:

when this was sufficiently baked in the sun, I poured my solution over it, which dried exactly as the natural encrustation does. When all was ready, I led my goat across the brittle surface, which broke precisely as I had seen it do down by the Dead Sea. The shallows, other than those round the animal's feet, were painted at Oosdoom.

'I wonder how you all go on in London,' he wrote to Millais. 'No Pre-Raphaelite Brotherhood meetings, of course ... I shall be glad to leave this unholy land, beautiful and interesting as it is.' But in fact, after further travels to Galilee, Damascus, Beirut, Istanbul and the Crimea, Hunt returned to Britain only in February 1856.

BELOW: *An obstinate mule, sketched by Holman Hunt in a letter to his son on Hunt's second trip to Palestine. The reluctant beast is loaded with artists' paraphernalia.*

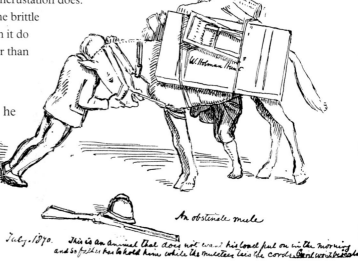

An obstinate mule

July. 1870. This is an animal that does not want his load put on in the morning and so father has to hold him while the muleteer ties the cords.

97

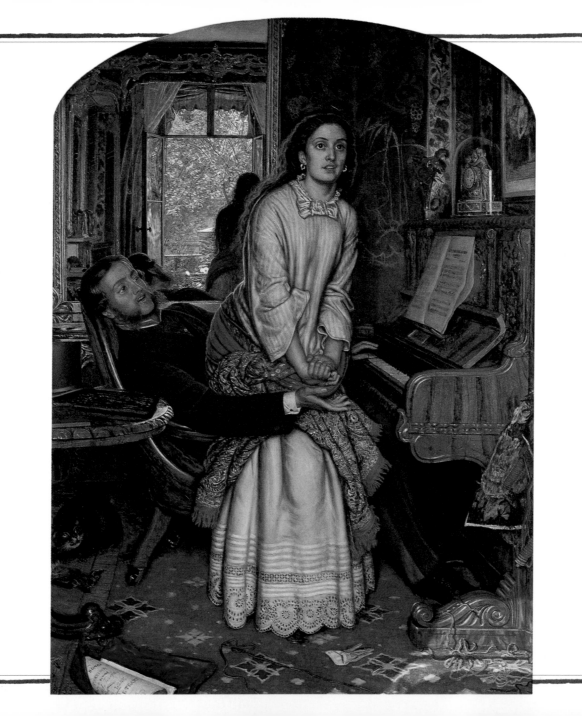

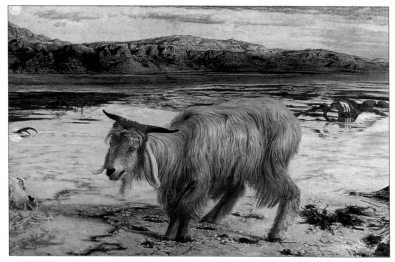

LEFT: The Awakening Conscience *(1854) by Holman Hunt. On the 'fallen woman' theme, this shows 'a young swell and his mistress' at her moment of moral realization and regret. 'He wore me like a silken knot, he changed me like a glove,' wrote Christina Rossetti in a poem on the same theme.*

LEFT: The Scapegoat *(1854–5) by Holman Hunt. 'The mountains beyond the sea ... under the light of the evening sun, shone in a livery of crimson and gold,' noted Hunt's companion; 'and then as if to complete the magnificence of the scene, a lofty and most perfect rainbow spanned the wide but desolate space.'*

'Hunt came back from Jerusalem with the addition of a cosmetic beard, and looking better settled in health,' wrote William Rossetti. *The Scapegoat* was his main submission to the Royal Academy, but did not meet with universal acclaim, William added with customary precision:

> *The Scapegoat* is a very remarkable picture. Ruskin, with all thick and thin upholding of Hunt, says it is only fit to be the sign of the Goat and Compasses; Woolner vows it is altogether ahead of anything Hunt had done before. I have only seen it twice ... the first time I was rather disappointed ... the second I liked it so much better that ... I believe lengthened acquaintance with it will make me rate it very high. With the public I fear it will be all but a failure, and certainly a theme for no little ridicule.

'A grand thing, but not for the public' was Gabriel's verdict, too.

Brown's diary described some other troubles, one day when several P.R.Bs interrupted. When they left Hunt stayed:

& told me about the Bishop of Jerusalem who seems to be one of the meanest scoundrels not yet in hell, then about his sale of the scape goat to White [a dealer] for 450 guineas at 8 months date – then about Annie Millar's love for him & his liking for her & perplexities & how Gabriel like a mad man increased them taking Annie to all sorts of places of amusement which he had implied if not stated should not be ... having allowed her to sit to Gabriel while he was away Gabriel has let her sit to others not in the list & taken her to dine at Bertolini's and to Cremorne [pleasure gardens] where she danced with [George] Boyce, & William takes her out boating ... They all seem mad about Annie Millar & poor Hunt has had a fever about it.

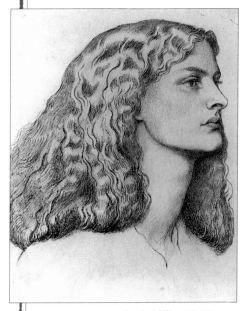

ABOVE: *Annie Miller (1860) by Rossetti. 'Dear Boyce, Annie and I have come with 1000 apologies; but really she must – do let her – sit to me tomorrow.'*

Annie Miller was the pretty daughter of an old soldier whom Hunt discovered serving in a pub behind his Chelsea studio. Reading her possible fate into the subject of his *Awakening Conscience*, for which she was the model, Hunt had arranged for her education during his absence, with the unspoken aim of making her his wife – or at the least saving her from a life of shame. Now it emerged that Gabriel and Annie had been amusing themselves at London's night-spots.

Neither Hunt nor Lizzie was amused. On 16 July Brown noted:

Emma called on Miss Sid yesterday who is very ill & complaining much of Gabriel. He seems to have transferred his affections to Annie Millar & does nothing [but] talk of her to Miss Sid. He is mad past care.

Ten days later he and Seddon arranged to go boating with Hunt, at whose house in Pimlico Brown met Annie, 'looking very siren-like'. By 8 September the contretemps seemed to be over:

Gabriel has forsworn flirting with Annie Millar it seems, Guggum having rebelled against it. He & Guggum seem on the best of terms now, she is painting at her picture [probably either 'The Ladies' Lament' from the *Ballad of Sir Patrick Spens*, or 'Lady Clare', from Tennyson].

ABOVE: *Annie Miller (1854) by George Boyce. In 1863 Annie married Captain Thompson, a 'very good gentlemanly fellow' according to Rossetti.*

But Gabriel had certainly been flirting with Annie and drawing her – for one of the attendants in his large watercolour of *Dante's Dream*. Perhaps Annie flirted too, in order to bring Hunt to a declaration. His confidant, Fred Stephens, wrote warningly of 'the utter hopelessness of your entering into a more sincere engagement with her unless she shows some sort of stability of character'. Hunt, however, proposed to continue paying for her education in the hope that the attempt at 'improvement' would succeed. It might, he replied, 'have such a happy issue if she would determine to give up wretched false pride and a fatal indolence'.

The problem, it seems, was that Annie perceived 'gentility' and lady-like manners to consist of leisure rather than work, whereas Hunt believed strongly in the Protestant work ethic as a route to financial security. Despite this fundamental divergence, their relationship continued for several months more, during which time Hunt painted Annie for a picture tellingly entitled *Il Dolce Far Niente* or *Sweet Idleness*.

To at least one observer, however, there was no visible lack of harmony between Hunt and his Pre-Raphaelite Brother Gabriel. As young Edward Jones told his father in the autumn of 1856:

> A glorious day it has been – a glorious day, one to be remembered by the side of the most notable ones in my life: for whilst I was painting ... in Rossetti's studio, there entered the greatest genius that is on earth alive, William Holman Hunt – such a grand-looking fellow, such a splendour of a man, with a great wiry golden beard, and faithful violet eyes – oh, such a man. And Rossetti sat by him and played with his golden beard passing his paint-brush through the hair of it. And all evening through Rossetti talked most gloriously, such talk as I do not believe any man could talk beside him.

A new phase of artistic friendship was opening.

ABOVE: *Caricature of Holman Hunt by Edward Burne-Jones, giving Hunt a curiously wraith-like look.*

Chapter Six

JOVIAL FRIENDS

ACCORDING TO ROSSETTI, Ned Jones was 'one of the nicest young fellows in – *Dreamland*'. For it was there, Rossetti went on, that most of the contributors to a new 'miraculous piece of literature' seemed to live. It reminded him of *The Germ*, and the latest number had a really remarkable story called 'A Dream'.

The Oxford and Cambridge Magazine, known to its intimates simply as 'The Mag', was indeed very like *The Germ* in being the creation of a group of idealistic young men with artistic ideas. Mostly university friends from Oxford, the moving spirits were Edward Burne-Jones, an aspiring painter originally from Birmingham (who later hyphenated his names in order to distinguish himself from the multitude of other Joneses), and William Morris, author of several stories and poems about medieval knights and ladies, including 'A Dream':

> She gazed down the line of the yew-trees and watched how, as he went for the most part with a firm step, yet he shrank somewhat from the shadows of the yews; his long brown hair flowing downward swayed with him as he walked; and the golden threads interwoven with it, as the fashion was with the warriors in those days, sparkled out from among it now and then; and the faint, far-off moonlight lit up the waves of his mailcoat ... then she heard the challenge of the warder, the falling of the drawbridge, the swing of the heavy wicket-gate on its hinges; and into the brightening lights, and deepening shadows of the moonlight he went down from her sight; and she left the porch and went to the chapel, all that night praying earnestly there.

On Ned's first visit to Chatham Place, Rossetti 'asked much about Morris, one or two of whose poems he knew already':

LEFT: *Designs for the decoration of Red House, done in watercolour by Burne-Jones around 1860. Among the projected ideas were scenes from Chaucer, the* Niebelungenlied *and a medievalized Siege of Troy.*

ABOVE: *Decorative design in one of William Morris's early sketchbooks, probably copied from a medieval source.*

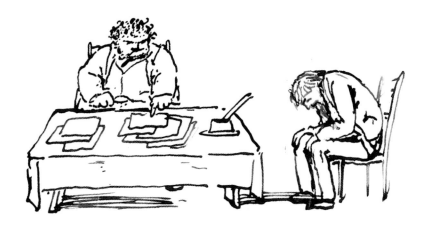

SED POETA TURPITER
SITIENS CANESCIT

ABOVE AND RIGHT: *Comic sketches of William Morris and Burne-Jones. From left: working together on a joint project; Morris carousing, with a note 'to JM from EBJ' and a message 'The above will be home about 2 tonight'; 'Grace before meal' and 'Disgrace after meal'.*

There was a lady lived in a hall,
Large in the eyes and slim and tall;
And ever she sung from noon to noon,
Two red roses across the moon.

There was a knight came riding by
In early spring, when the roads were dry;
And he heard that lady sing at noon,
Two red roses across the moon.

As possessor of a substantial income from family investments, Morris was far and away the richest recruit to the Pre-Raphaelite ranks. In 1856 he purchased Arthur Hughes's *April Love* and one of Madox Brown's landscapes. 'Yesterday Rossetti brought his ardent admirer Morris of Oxford, who bought my little hay field for 40 gns,' Brown recorded on 24 July.

Morris's nickname was 'Topsy', like the child in *Uncle Tom's Cabin* who 'spect I grow'd', apparently in allusion to his tendency to put on

Grace before meal.

Disgrace after meal

weight. Both he and Burne-Jones were in awe of Rossetti. Ned recalled Rossetti showing him designs that were tossed everywhere in the room:

> the floor at one end was covered with them, and with books. No books were on the shelves, and I remember long afterwards he said that books were no use to a painter except to prop up models in difficult positions ... I stayed long, and watched him at work, not knowing till many a day afterwards that this was a thing he greatly hated – and when for shame I could stay no longer, I went away, having carefully concealed from him the desire I had to be a painter.

Gabriel, who encouraged all artistic ambitions, quickly adopted his new disciples. To a college friend Morris described his own initiation into the Pre-Raphaelite circle:

> I have seen Rossetti twice since I saw the last of you; spent almost a whole day with him, the last time, last Monday, that was. Hunt came in while we were there, a tallish, slim man with a beautiful red beard ...

a beautiful man. Rossetti says I ought to paint, he says I shall be able; now as he is a very great man and speaks with authority and not as the scribes, I *must* try. I don't hope much, I must say, yet will try my best – he gave me practical advice on the subject ... Ned and I are going to live together. I go to London early in August.

Eventually, after lodging for a while elsewhere, they took the same rooms in Red Lion Square that Gabriel had once shared with Walter Deverell. And during the early weeks of their acquaintance Gabriel introduced his new friends to the entertainments of London. Sometimes, at the theatre, Ned recalled:

he would grow sick of the play if it was a silly one and propose that we should leave it at once, which through worship of him we always assented to obediently, though much wanting to know how the story ended. And sometimes we roamed the streets, and sometimes went back to Blackfriars to Gabriel's rooms and sat till three or four in the morning, reading and talking. Our Sundays were very peaceful days ... often spent by Morris in reading aloud the Morte d'Arthur while I worked.

Malory's *Le Morte D'Arthur* was their favourite book, quickly introduced to Rossetti, who promptly began a series of watercolours on chivalric themes: *The Tune of Seven Towers, The Damsel*

LEFT: April Love *(1855) by Arthur Hughes. Although this depicts a lovers' tiff, the model for the young woman was Hughes's wife Tryphena, whom he married soon after the painting was completed.*

RIGHT: *The Blue Closet (1857), a watercolour by Rossetti inspired by medieval illumination. The blue tiles anticipate those produced later by Morris & Co.*

of the Sanct Grael and *The Blue Closet.* To some of these images Morris wrote verses:

> *If any will go to it now,*
> *He must go to it all alone,*
> *Its gates will not open to any row*
> *Of glittering spears – will you go alone?*
> 'Listen!' said fair Yolande of the flowers,
> 'This is the tune of Seven Towers'.

Ned was engaged to Georgiana Macdonald, usually called Georgie. She recalled nostalgically that life at Red Lion Square was free and happy. It was, however, underpinned by the good sense and originality of the housekeeper, Mrs Nicholson, always known as 'Red Lion Mary', who kept disorder at bay.

Their rough and ready hospitality was seconded by her with unfailing good temper; she cheerfully spread mattresses on the floor for friends who stayed there, and when the mattresses came to an end it was said that she built up beds with boots and portmanteaus. Cleanliness, beyond the limits of the tub, was impossible in Red Lion Square and hers was not a nature to dash itself against impossibilities, so the subject was pretty much ignored, but she was ready to fulfil any mission or do anything for them at a moment's notice ... 'Mary!' cried Edward one evening when ordering breakfast overnight for Rossetti, who was staying with them, 'let us have quarts of hot coffee, pyramids of toast, and multitudinous quantities of milk'; which to her meant all he intended.

Not surprisingly, both Georgie and Ned remembered these days at Red Lion Square as supremely happy. Later years would be clouded by troubles and responsibilities, but:

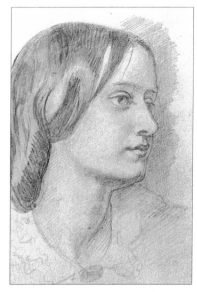

ABOVE: *'Red Lion Mary' by Rossetti. According to Janey Morris, this was an excellent likeness, although perhaps somewhat 'improved', as Mary was generally regarded as too plain to be a model.*

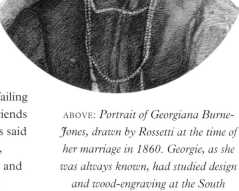

ABOVE: *Portrait of Georgiana Burne-Jones, drawn by Rossetti at the time of her marriage in 1860. Georgie, as she was always known, had studied design and wood-engraving at the South Kensington art school.*

The year of 1856 that looks so fair in memory seemed equally beautiful to us in reality. Recalling long after youth was past, Edward deliberately wrote: 'There was a year in which I think it never rained nor clouded, but was blue summer from Christmas to Christmas, and London streets glittered, and it was always morning, and the air sweet and full of bells.'

In June 1857 the Pre-Raphaelite artists held their own show – an untitled exhibition salon at a small gallery near Fitzroy Square. The exhibitors included Millais, Hunt, Brown, Hughes, Charles Collins, George Boyce, John Brett, Elizabeth Siddal and Rossetti, who wrote urgently to Morris, then struggling to paint a tree in the garden of a friend in Summertown, Oxford:

ABOVE: *The studio at Red Lion Square, immortalized by Burne-Jones. 'It is a faithful record of the general aspect of the room,' noted Georgie, 'with Edward himself looking with devouring interest at a picture with which Rossetti has glorified one of the chairs that Morris designed.' To the right is an artist's lay-figure warming its wooden legs at the fire.*

And how goes it with you? And are you going it still at your picture?

You know our little Exhibition opens here on Monday, and I want much to send the *Blue Closet*, as everyone advises. Could you get it *at once* for me, and have it sent to London by *Friday* – to 4 Russell Place, Fitzroy Square? Will you now? I am going to send several others, but I hardly know which, yet.

Shouldn't I like to come to Oxford – and ain't I seedy! but I must touch up drawings now till Monday. *Friday* is the hanging day – so *Blue Closet* should be there by then.

Shortly after this Rossetti joined Morris in Oxford, where, it seems, they bounced the University debating society into allowing them to

decorate its new building with scenes from Malory. As Rossetti wrote to Barbara Bodichon, an old friend:

> What do you think I and two friends of mine are doing here? Painting pictures nine feet high with life-size figures, on the walls of the Union Society's new room here ... The work goes very fast, and is the finest fun possible. Our pictures are from the *Morte d'Arthur*.

As well as Morris and Burne-Jones, several other artists participated in this 'jovial campaign', including J. R. Spencer Stanhope and Arthur Hughes. The youngest recruit was nineteen-year-old Val Prinsep, who lodged at the Mitre. 'What fun we had!' he recalled. 'What jokes! What roars of laughter!' He remembered the first evening, when he dined with the others in their lodgings:

> There I found Rossetti in a plum-coloured frock-coat, and a short square man with spectacles and a vast mop of dark hair. 'Top', cried Rossetti, 'let me introduce Val Prinsep'.
>
> 'Glad, I'm sure' answered the man in spectacles, nodding his head, and then he resumed his reading of a large quarto. This was William Morris. Soon after, the door opened and before it was half opened in glided Burne-Jones. 'Ned', said Rossetti, who had been absently humming to himself, 'I think you know Prinsep'. The shy figure darted forward, the shy face lit up.

When dinner was over, Rossetti, humming to himself as he often did, rose from the table and proceeded to curl himself up on the sofa.

> 'Top', he said, 'read us one of your grinds'. 'No, Gabriel', answered Morris, 'you have heard them all'. 'Never mind', said Rossetti, 'here's Prinsep who has never heard them, and besides, they are devilish good'. 'Very well, old chap', growled Morris, and having got his book he began to read ...

ABOVE: *Study for* Lancelot's Vision of the Holy Grail, *mural painting for Oxford Union debating chamber by Rossetti. 'Who else in the world could have designed Guenevere who stands in the branches of the Tree of Temptation hiding the vision of the Grail from her lover?' wrote Burne-Jones.*

RIGHT: Before the Battle *(c.1858) by Elizabeth Siddal. A companion piece to Rossetti's picture of the same subject, this shows a medieval couple tying a red pennant to the Knight's lance.*

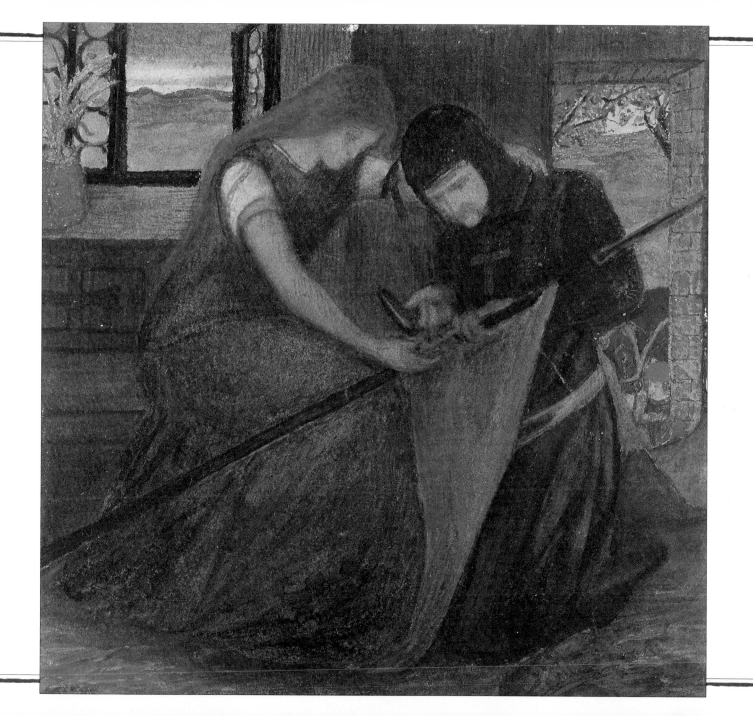

BELOW: '*I did love you once*', says
*Hamlet to Ophelia, as she returns
his betrothal gifts. In this highly
finished drawing, Rossetti appears to
dramatize his own feelings for Lizzie.
In the background two snaking
stairways touch but do not join.*

*Gold on her head and gold on her feet
And gold where the hems of her kirtle meet
And a golden girdle round my sweet
Ah, quelle est belle La Marguerite!*

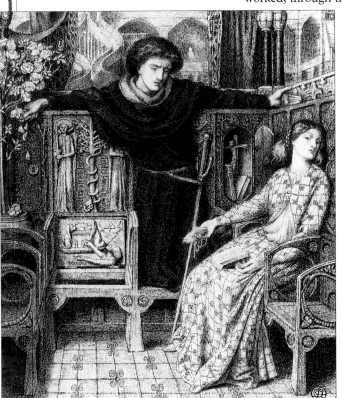

Being unskilled in the art of mural painting, they failed to prepare the surface, so that the images soon began to flake and fade. But while they worked, through the long vacation and on into the autumn, a good time was had by all. In November, however, before the task was completed, Rossetti left Oxford for Sheffield, where Lizzie was visiting relatives. They spent the next few months together in Derbyshire, at the spa town of Matlock, painting complementary watercolours on the chivalric theme of knights parting from their ladies.

Another of Gabriel's drawings at this time depicted the end of Hamlet's betrothal to Ophelia – an ominous subject which obliquely indicated that all was not well between himself and his 'dear dove'. Earlier quarrels over Annie Miller had developed into arguments over marriage, as Gabriel refused to set a date for the wedding. By the end of 1856, as Brown's diary records, Lizzie 'determined to have no more to do with him' and left for Bath. Gabriel followed, renewing his promises; but still no action followed. Then came a proposal for a Pre-Raphaelite 'college' or community, where several artists would live and work in companionable proximity.

No joint residence was established. The truth was that Gabriel had fallen out of love. Lizzie's misery seems to be expressed in her verses:

Many a mile over land and sea
Unsummoned my love returned to me;
I remember not the words he said
But only the trees moaning overhead.

I felt the wind strike chill and cold
And vapours rise from the red-brown mould;
I felt the spell that held my breath
Bending me down to a living death.

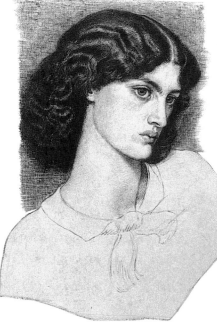

ABOVE: *Portrait of Jane Burden, drawn by Rossetti in 1858, during the time of her engagement to William Morris.*

Although they were together for several months in the North, there was no further talk of marriage. We do not know exactly what happened at Matlock, but it appears the breach was now irreparable.

Back in Oxford, the jovial crew had acquired a new follower in Algernon Swinburne, student and aspiring poet, who eagerly allied himself to the Pre-Raphaelite cause. One evening, he remembered, after work in the debating chamber, they had a 'great talk' in which he and Ned fiercely defended their 'idea of heaven, viz. a rose-garden full of stunners'. This was Gabriel's term for a pretty girl; as Val Prinsep recalled, 'we copied his very way of speaking. All beautiful women were "stunners" with us.'

One stunner Gabriel had spotted in Oxford was black-browed Jane Burden, the seventeen-year-old daughter of a stableman. Prevailed upon to sit to the artists, she was drawn as Guenevere by Gabriel and on his departure inherited, as it were, by Morris, who began to paint her as La Belle Iseult. Shy with women, Morris is said to have written a message to Jane on the back of his canvas: 'I cannot paint you, but I love you.'

According to William Rossetti:

My brother was the first to observe her. Her face was at once tragic, mystic, passionate, calm, beautiful and gracious – a face for a sculptor,

ABOVE: *Morris's own, less accomplished portrait of Jane, also done in 1858. 'Imagine ... a mass of crisp black hair heaped into great wavy projections ... a thin pale face, a pair of strange, sad, deep, dark Swinburnian eyes,' wrote Henry James after meeting Jane.*

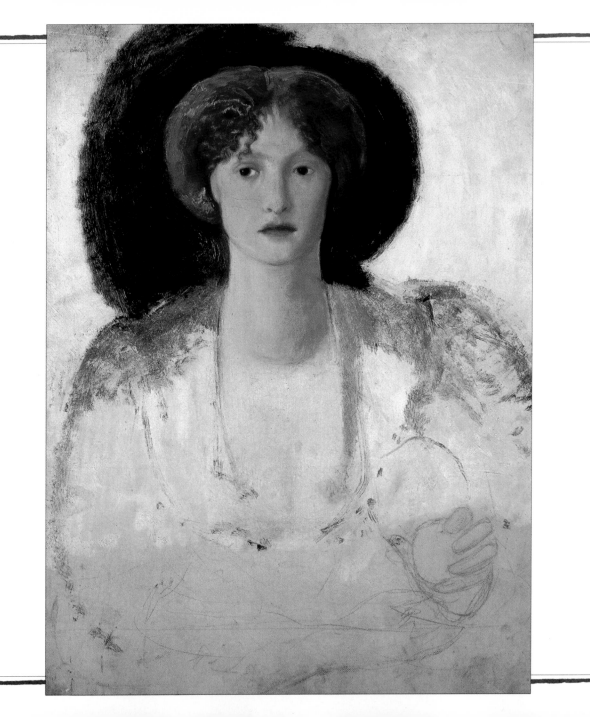

and a face for a painter – a face solitary in England ... Her complexion was dark and pale, her eyes a deep penetrating grey, her massive wealth of hair gorgeously rippled and tending to black, yet not without some deep-sunken glow.

LEFT: Hope, *an unfinished canvas by Burne-Jones dating from 1861–2. The title is allegorical, although the figure seems to be holding an apple and may be intended as an image of carnal allure. Fanny Cornforth was the model.*

The others observed the courtship with some amusement. Swinburne wrote that he was glad:

> to think of Morris's having that wonderful and most perfect stunner of his to – look at or speak to. The idea of his marrying her is insane. To kiss her feet is the utmost man should dream of doing.

But this was no mock-medieval chivalrous romance; Morris was not a man to be deflected once he had made up his mind. His wedding to Jane took place in Oxford in April 1859.

The previous summer Rossetti had returned to London. And soon a new stunner appeared on the scene – buxom, golden-haired Fanny Cornforth. Fanny belonged to 'the oldest profession', and was plying her trade one evening when she was first seen, according to Bell Scott:

> cracking nuts with her teeth, and throwing the shells about. Seeing Rossetti staring at her, she threw some at him. Delighted with this brilliant naiveté, he forthwith accosted her, and carried her off to sit to him for her portrait.

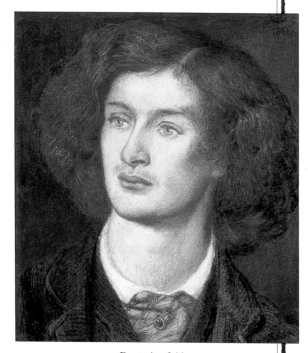

ABOVE: Portrait of Algernon Swinburne *(1861) by Rossetti. Expelled from Oxford for his dissolute behaviour, Swinburne joined forces with the Pre-Raphaelites, who regarded him with amused affection.*

Fanny herself later described a meeting in which she encountered 'a party of four artists', including Rossetti, Brown and Burne-Jones, who were so attracted 'by the great beauty of this country girl, and especially by her great wealth of magnificent golden hair' that 'one of them, "accidentally on purpose" in passing behind her gave it a touch with his fingers so that it all fell down her back'.

The result was 'apologies and a conversation' and the next day she went to Rossetti's studio, where 'to use her own expression "he put my head against the wall and drew it for the head in the calf picture" '.

This was the unfinished *Found*, laid aside at the end of 1854. It appears that Fanny's profession – and perhaps her history, as a poor country girl lured by the bright lights into a life of shame – inspired Rossetti to take up his old subject. Soon, however, he was painting her in far more sensuous mode, as an alluringly lovely and seductive figure. This, wrote Scott, led to his 'paradoxical conclusion that women and flowers were the only objects worth painting'.

William contested this view, saying that 'the gentlemen who commissioned or purchased the pictures [were] chiefly responsible for this result'. He also defended Fanny who, although 'lacking all charms of intellect or breeding', was good-natured and

pre-eminently a fine woman, with regular and sweet features, and a mass of the most lovely blonde hair – light-golden or 'harvest yellow'. *Bocca Baciata* which is the most faithful portrait of her, might speak for itself.

Fanny's advent was reflected in Gabriel's poems, too, starting with his new version of 'Jenny' about a young student and a street girl:

> *Why, Jenny, as I watch you there –*
> *For all your wealth of loosened hair,*
> *Your silk ungirdled and unlac'd*
> *And warm sweets open to the waist*
> *All golden in the lamplight's gleam –*
> *You know not what a book you seem,*
> *Half-read by lightning in a dream!*

ABOVE: *Fanny Cornforth with George Boyce (1858), ink drawing done by Rossetti in Boyce's studio off The Strand. Artists and model frequently made a threesome, visiting the Zoo or Cremorne Gardens.*

LEFT: *Burne-Jones's study of Fanny Cornforth (1861), posed and costumed for the painting* Laus Veneris, *based on the Tannhäuser legend.*

Another admirer of Fanny was George Boyce, who joined Rossetti in bohemian pursuits, as his diary records:

DECEMBER 15 1858
To Rossetti. The new things I noticed were an intensely impressive water colour of the Virgin in the house of John ... [and] a Knight girded for combat embracing his Lady Love ... We went off at dusk and dined at the Cock, and afterwards adjourned to 24 Dean St, Soho, to see 'Fanny'. Interesting face and jolly hair and engaging disposition.

JANUARY 17 1859
[Burne-] Jones showed me the commencement of a pen and ink drawing for Ruskin – subject from Florentine history [*Buondalmente's Wedding*]. I gave him a commission for a water colour drawing for 15 gns [probably

The Goldfish Pool]. Went into the Argyle Rooms [at Piccadilly Circus]. There met Fanny and took her to supper at Quinn's. She was in considerable trepidation lest Rossetti should come in – and lo! he did so.

FEBRUARY 11
Went to see Fanny and gave her a sovereign to help her in the furnishing of her new house.

Later that year Boyce commissioned Gabriel to paint 'a splendid portrait of Fanny in late 16th century costume'– the finished picture *Bocca Baciata*, or *The Much-kissed Mouth*, which startled even the artistic community with its frank sensuality. Swinburne wrote to Scott at the end of the year:

> I had a jolly fortnight in London ... and saw D.G.R's new poems and pictures. I daresay you have heard of his head in oils of a stunner with flowers in her hair, and marigolds behind it? She is more stunning than can be decently expressed.

Early in 1860 the Browns invited Georgie Macdonald to visit them for a month. 'I am sure Georgie would be glad beyond words to go and stay with you any time you ask,' Ned replied on her behalf; 'it is immensely kind of you and Mrs Brown – an invitation would be grabbed at by her I know.' And Georgie herself had warm memories of the visit:

> a small house and slender means were made spacious and sufficient by their generous hearts, and my recollection is of one continuous stream of hospitality. Who that was present at it could ever forget one of the dinners, with Madox Brown and his wife seated at either end of a long table, and every guest a welcome friend who had come to talk and to laugh and to listen? for listening was the attitude into which people naturally fell when in his company. He had so much to say and was so happy in saying it that sometimes he would pause, carving knife in

ABOVE: *Arthur Hughes suggested that George Boyce might be tempted 'to kiss the dear thing's lips away' when he took possession of* Bocca Baciata. *This was a first example of the frankly sensuous painting for which Rossetti became famous.*

RIGHT: Bocca Baciata *(1859) by Rossetti. A faithful likeness of Fanny Cornforth, inspired by a tale from Boccaccio, this bears an Italian quotation: 'The mouth that has been kissed loses not its freshness; still it renews itself as does the moon', in oblique reference to sexual pleasure.*

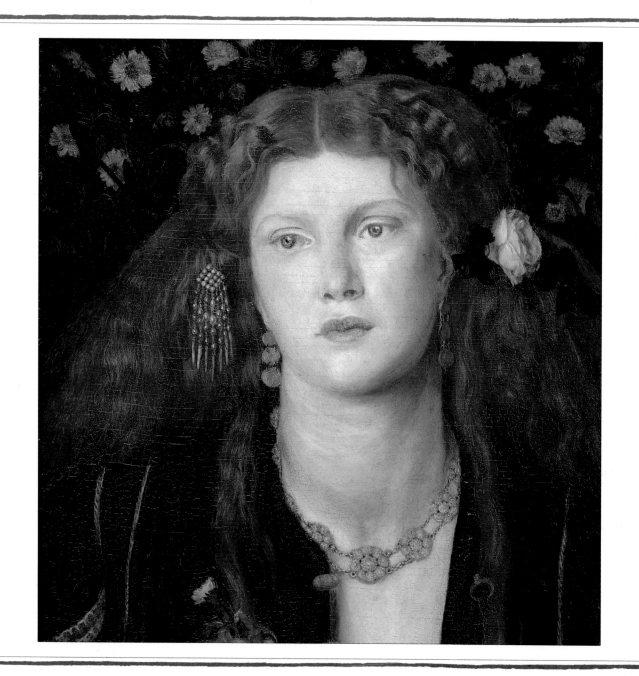

hand, until Mrs Brown's soft voice could be heard breathing his name from her distant place and reminded him of his duties.

Before Georgie's visit ended, the Browns had dec that she and Edward should marry forthwith. So the decision was taken, and at the same time they were surprised and delighted to learn that Gabriel and Lizzie were also to marry 'in as short a time as possible'. Without any word of explanation, Gabriel was back with Lizzie, at Hastings, where they had once been so happy. She was very sick, with vomiting and weakness. As Gabriel told his mother:

> Like all the important things I ever meant to do – to fulfil duty or secure happiness – this one has been deferred almost beyond possibility. I have hardly deserved that Lizzy should still consent to it, but she has done so, and I trust I may still have time to prove my thankfulness to her. The constantly failing state of her health is a terrible anxiety indeed; but I must still hope for the best, and am at any rate at this moment in a better position to take this step, as regards money prospects, than I have ever been before.

He did not add his main cause for concern – Lizzie's now severe addiction to laudanum, an opiate drug. There were many moments when she was hardly expected to live. But on 23 May 1860 they were finally married, and went to Paris, where Gabriel drew a dark *doppelgänger* image of two lovers meeting their doubles – a sure presage of death – inscribed with the dates of their meeting and marriage: 1851–1860. At last, Gabriel had made good his promises.

After the honeymoon they returned to London, taking lodgings in Hampstead. In July Georgie Burne-Jones first met Lizzie, who proved 'as beautiful as imagination'. The two couples had a joint rendezvous at the Zoo, 'hard by the wombat's lair'. Later Georgie wrote:

RIGHT: How They Met Themselves *(1860), an ominous* doppelgänger *image drawn by Rossetti in Paris. Simultaneously Lizzie was designing a tragic medieval scene entitled* The Woeful Victory.

JOVIAL FRIENDS

I wish I could recall more details of that day – of the wombat's reception of us and of the other beasts we visited – but can only remember a passing call on the owls, between one of whom and Gabriel there was a feud. The moment their eyes met they seemed to rush at each other.

Back in Hampstead, Georgie was led upstairs by Lizzie:

I see her in the little upstairs bedroom with its lattice window, to which she carried me when we arrived, and the mass of her beautiful deep-red hair as she took off her bonnet: she wore it very loosely fastened up, so that it fell in soft, heavy wings. Her complexion looked as if a rose tint lay beneath the white skin, producing a most soft and delicate pink for the darkest flesh tone. Her eyes were of a kind of golden brown – agate-colour is the only word I can think of to describe them.

Whilst we were in her room she showed me a design she had just made, called 'The Woeful Victory' .

'Indeed and of course my wife *does* draw still,' Rossetti insisted to William Allingham:

Her last designs would I am sure surprise and delight you, and I hope she is going to do better now than ever. I feel surer every time she works that she has real genius – none of your make-believe – in conception and colour and if she can only add a little more of the precision in carrying out which it so much needs health and strength to attain, she will I am sure paint such pictures as no woman has painted yet.

The next few months were full of gaiety, with much theatre-going and entertaining. On one occasion Lizzie wrote to invite her new friend:

ABOVE: *Study of Elizabeth Siddal, inscribed 'Hastings 1860', by Rossetti. 'If I were to lose her now,' he wrote, 'I should have so much to grieve for and what is worse so much to reproach myself with.'*

My dear little Georgie

I hope you intend coming over with Ned tomorrow evening like a sweetmeat, it seems long since I saw you dear. Janey will be here I hope to meet you.

With a willow pattern dish full of love to you and Ned –
Lizzie

They shared a passion for 'common English willow-pattern' china, which at the time was despised as kitchen ware. This was partly in protest against standard Victorian design and it was also in keeping with their income, for this was 'before the days of real Chinese ware for any of us'.

This year William and Janey Morris moved into their new home, Red House in Kent, which was designed for them by Philip Webb. It became an enchanted habitation for the whole group of friends, as Morris's biographer records:

One of the most potent images of Red House is of Morris coming up from the cellar before dinner, beaming with joy, with his hands full of bottles of wine, and more bottles tucked under his arm ... the reincarnation of the medieval host.

The dining-room was not yet finished, Georgie recalled, and the large upstairs drawing-room was still being decorated:

so Morris's studio, which was on the same floor, was used for living in, and a most cheerful place it was, with windows looking three ways and a little horizontal slip of a window over the door, giving upon the red-tiled roof of the house where we could see birds hopping about all unconscious of our gaze.

The Morrises' first child was born in January 1861. Emma Brown went to assist. As the proud, if laconic, father wrote to Brown:

ABOVE: *Red House, Bexleyheath, Kent, from the garden, with the red-tiled well in the centre. The exterior of the house stands virtually unchanged since it was built for William Morris.*

ABOVE: *Flower design from William Morris's sketchbook now in the British Library.*

RIGHT: Dantis Amor *(1860) centre panel painted by Rossetti for a cabinet at Red House. Love stands in the centre, with Christ looking down from heaven as Beatrice ascends through the stars.*

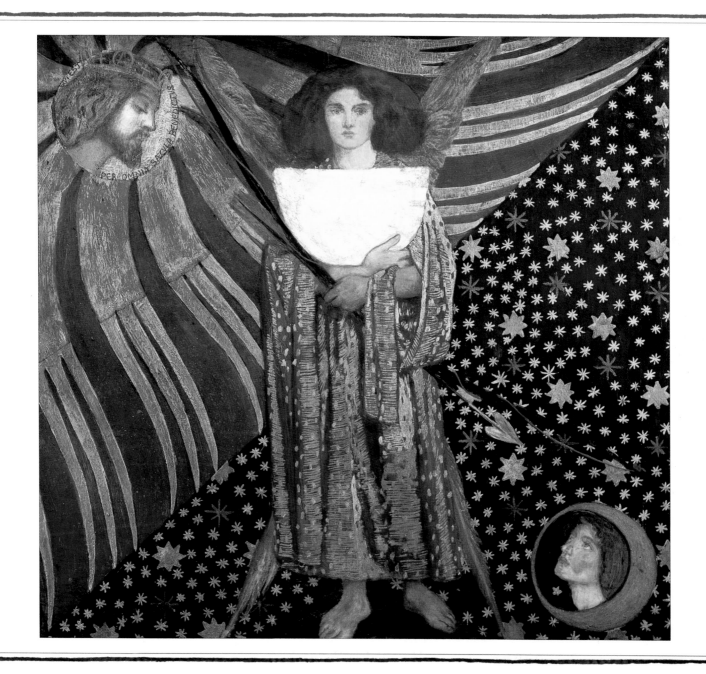

Kid having appeared, Mrs Brown kindly says she will stay till Monday, when you are to come to fetch her please. I send a list of trains in evening to Abbey Wood met by bus, viz., from London Bridge, 2.20 p.m., 4.20 p.m., 6.0 p.m., and 7.15 p.m. Janey and kid (girl) are both very well.

'Kid (girl)' was named Jane Alice, but was always known as Jenny. Just over a year later she acquired a younger sister, named May.

Lizzie and Gabriel were not as lucky as Janey and William. Their daughter was stillborn. 'My dear Brown,' wrote Gabriel:

Lizzie has just had a dead baby ... Of course she has to be kept very quiet, but I daresay she would be very glad if Emma could look in for a little tomorrow. Perhaps evening would be best.

This loss, coupled with Lizzie's opium addiction, appears to have disturbed the balance of her mind. Eight months later a second tragedy took place. Gabriel spent a terrible night trying to save her life. The next day, summoned to Blackfriars, William saw his sister-in-law lying 'wonderfully calm and beautiful' like a vision from Dante's account of the death of Beatrice:

ABOVE: *Janey, comfortably seated in a tub chair sewing, drawn by Rossetti.*

ABOVE: *Burne-Jones's caricature of William Morris with his daughters at Red House.*

Ed avea in se umilta si verace
Che parea che dicesse, Io sono in pace.
(And with her was such very humbleness
That she appeared to say, I am at peace.)

'I could not but think of that all the time I looked at her, it is so exactly like,' William noted in his diary.

'Dear Stephens,' he told his old Pre-Raphaelite Brother the same day, 'Poor Lizzie is dead: you will see about it in the paper unfortunately – laudanum.' A day or so later he wrote again:

> You will pardon my having been so abrupt ... The poor thing had been in the habit of taking laudanum for more than 2 or 3 years past in considerable doses, and on Monday she must have taken more than her system could bear. Gabriel, on returning home late at night from the Working Men's College, found her in a hopeless state, and all the efforts of 4 doctors for 7 hours availed nothing ...
>
> The funeral is to be on Monday, after which I doubt whether Gabriel will ever reinhabit Chatham Place.

Swinburne, who had dined with Gabriel and Lizzie the evening before, was a witness at the inquest. 'I would rather not write yet about what has happened,' he told his mother:

ABOVE: *Elaborate flower study in Morris's 1860 sketchbook, perhaps from a medieval source.*

> I was almost the last person who saw her (except her husband and a servant) and had to give evidence ... Happily there was no difficulty in proving that illness had quite deranged her mind.

William's terse diary contained the sequel:

> FEBRUARY 17.
> The funeral. Grave 5779, Highgate [the Rossetti family grave].
> Gabriel put the book of his MS poems into the coffin.

Brown protested against this final gesture of regret – and possibly remorse – but William supported his brother, saying 'the feeling does him honour, and let him do as he likes'.

Whatever the feeling, it was an action born out of sorrow that would cause Gabriel much anguish. And Lizzie's sad death marked the end of a Pre-Raphaelite chapter, as well as the beginning of a legend that would, in due course of time, prove as haunting as his images of her.

Chapter Seven

THE FIRM

LEFT: St George leading the Princess, after slaying the dragon. Painted by Morris on a cabinet for Red House, now in the Victoria and Albert Museum. Designed in a deliberately archaic style, painted furniture featured among Pre-Raphaelite endeavours to transform interior decoration.

THE NEXT PRE-RAPHAELITE venture was a business enterprise – an artistic partnership set up to design, manufacture and sell decorative art, orginally named Morris, Marshall, Faulkner and Co. 'The Co. gets on; have you heard of the Co?' wrote Burne-Jones to a friend who was teaching in Russia:

> It's made up of Topsy, Marshall, Faulkner, Brown, Webb, Rossetti and me – we are partners and have a manufactory and make stained glass, furniture, jewellery, decoration and pictures; we have many commissions and shall probably roll in yellow carriages by the time you come back.

Rolling in yellow carriages was an allusion to the fabled conveyance of millionaire Isaac Singer, of sewing-machine fame. The company in which Ned, Topsy and the rest were partners was on more modest and indeed different lines, devoted not to mass production but to the integration of art and design – in Rossetti's words, 'to give real good taste at the price as far as possible of ordinary furniture'.

Ned ascribed the genesis of the idea to Red House:

> It was from the necessity of furnishing this house that the firm Morris Marshall, Faulkner and Co., took its rise. There were the painted chairs and the great settle ... The walls were bare and the floors; nor could Morris have endured any chair, table, sofa or bed, nor any hangings such as were then in existence. I think about this time Morris' income that was derived from copper mines began to diminish fast, and the idea came to him of beginning a manufactory of all things necessary for the decoration of a house. Webb had already designed some beautiful table-glass, metal candlesticks, and tables for Red House, and I had

ABOVE: *Interior at The Grange, the Burne-Joneses' house in Fulham, a watercolour by Thomas Rooke. Visible in the doorway is the embroidered hanging of St Catherine, originally made for Red House.*

already designed several windows for churches, so the idea grew of putting our experiences together for the service of the public.

The first wares were successfully shown in the Medieval Court at the 1862 International Exhibition in London, and 'the Firm', as it was familiarly known, was established at 8 Red Lion Square. Morris wrote to a prospective client:

> By reading the enclosed [prospectus] you will see that I have started as a decorator, which I have long meant to do when I could get men of reputation to join me ... In about a month we shall have some things to show you in these rooms, painted cabinets, embroidery and all the rest of it.

The Firm was in great activity, Georgie reported on her return from a trip to Italy with Ruskin:

> [It] had received two medals for what it shewed at the International Exhibition, and many commisssions from it were waiting for Edward; amongst them one for coloured tiles which proved a welcome outlet for his abounding humour, and in this form the stories of Beauty and the Beast and Cinderella took at his hands as quaint a shape as they wear in the pages of the Brothers Grimm of blessed memory.

Stained glass was also in demand, for houses as well as churches. All the partners collaborated on a sequence of windows telling the tale of King Mark, Sir Tristram and La Belle Iseult from Malory's *Morte D'Arthur*. Together with textiles and wallpaper designs, glass was to be the most distinctive of the Firm's products. As Morris explained later, the principles of good stained glass were 'absolute blackness of outline', good figure grouping and clear, bright colour.

The women also shared in the Firm's production. Jane Morris and her sister Bessie soon took charge of supervising the embroidery commissions. Georgie joined Kate and Lucy Faulkner in painting tiles,

LEFT: *Sketch for the embroidered hanging* The Legend of Good Women *designed by Burne-Jones for Ruskin. To the right of Chaucer, Love and Alcestis comes 'a tree and a vision of ladies, all to have scrolls with their names'.*

ABOVE AND LEFT: *Caricatures by Burne-Jones in the style of stained-glass cartoons, showing Morris plump and prosperous and Burne-Jones a thin and starving prisoner. The allegedly meagre fees earned by Burne-Jones for window designs for Morris & Co were a running joke.*

and after a while Kate became a designer and decorator in her own right. Jane warmly recalled the early days:

> The first stuff I got to embroider on was a piece of indigo-dyed blue serge I found by chance in a London shop ... I took it home and he [Morris] was delighted with it and set to work at once designing flowers. These we worked in bright colour in a simple rough way. The work went quickly.

In his quest for high quality of design and manufacture Morris, who was the Firm's business manager as well as principal pattern-maker, involved himself in all the processes, especially when in later years the Firm began producing carpets and large-scale tapestries in the medieval style. His care for fast, yet not garish, colours is illustrated in a letter to his supplier Thomas Wardle, dyer:

> I am sending today patterns for the warp and shoot [i.e. weft] of a blue carpet and the wools are ordered for it (2 pieces, 200 yds i.e.). The

BELOW: Tile panel illustrating Beauty and the Beast, designed by Burne-Jones for Morris & Co. The aptly-named Grimms' Fairy Tales were among the Pre-Raphaelites' favourite books.

RIGHT: 'The noblest of the weaving arts is tapestry,' wrote Morris; 'it may be looked upon as a mosaic of pieces of colour.' This acanthus leaf design, jokingly known as 'Cabbage and Vine' was his first tapestry.

How there was a Prince who by enchantment was turned into a bear & how a merchant was made to bring to him his youngest daughter and how the Prince became a man again and married her.

LEFT: *Burne-Jones's sketch of a larger-than-life wombat, bounding beside the Pyramids. Rossetti's pet wombat inspired many flights of fancy, including an Italian ode by Christina Rossetti beginning 'O uomibatto, hirsute e tondo!'*

thing to set you going fairly will be the greens; I am hard at work on the patterns for them, but have only got a big Bourges pot for my vat and find the wool-dyeing troublesome in it because the sediment kicks up so: in about a fortnight however I will send them on as fast as I can: by the way a bit of yellow dyed with bark-liquor has already yielded to the light in our window, so we must stick to weld for the present, I think: we are sending you patterns for a *little* bit of indigo silk-dyeing, which I hope as well as the green cotton skeins you will be able to do straight out: we mustn't mind the stripiness of the blue too much just at first.

Rossetti was now living by the Thames, at Chelsea, in the same old house with an extensive garden that he and his companions had coveted in the early days of the P.R.B. William wrote to Scott:

You must know Cheyne Walk, Chelsea, and may perhaps be aware that it is a place which Gabriel – and indeed Praeraffaelism [*sic*] generally – has always had a special itch for. There is a huge garden, covering, some say (though others tell me that is out of the question) more than 2 acres ... a drawing-room with seven windows' frontage and a large room on the ground floor, either of which would make a fine studio.

Here, in the garden, Gabriel acquired a menagerie of animals, domestic and exotic, which did not always coexist happily. 'Fancy, I had the

THE FIRM

loveliest little owl, a delightful ball of feathers, and my raven bit its head off,' he reported on one occasion. The peacocks proved too noisy, and the precious wombat died prematurely, despite being given the run of the house as well as the garden. Christina Rossetti feared he might try to burrow his way back to Australia, his antipodean home.

Among the human inhabitants, Fanny Cornforth was restored to what she regarded as her rightful position as Gabriel's disreputable but fun-loving mistress. As she grew stouter, he began calling her 'dear Elephant' (from EleFANt). William Allingham's diary for 1864 contains snapshot views of the whole Pre-Raphaelite circle:

MONDAY JUNE 27 –
Got down to Chelsea by half-past eight to D.G.R.'s. Breakfasted in a small lofty room on the first floor with window looking on the garden. Fanny in white. Then we went into the garden and lay on the grass, eating strawberries and looking at the peacock. F. went to look at the 'chicking', her plural of chicken. Then Swinburne came in, and soon began to recite – a parody on Browning was one thing; and after him Whistler, who talked about his own pictures – Royal Academy – the Chinese painter-girl, Millais, etc. I went off to Ned Jones's, found Mrs Ned and Pip, and F. Burton; talked of Christianity, Dante, Tennyson and Browning, etc.

SUNDAY JULY 17
By steamer to London Bridge and rail to Plumstead; after some wandering, find the Red House at last in its rose-garden, and William Morris, and his queenly wife crowned with her own black hair.

Plans were being laid for the Burne-Joneses to join the Morrises at Red House. Philip Webb drew up plans for a new wing enclosing the garden courtyard. Then Morris fell ill with rheumatic fever, while Georgie went

ABOVE: *Swinburne, Gabriel, Fanny and William Rossetti, photographed in the garden at Cheyne Walk.*

ABOVE: *Rossetti's elegy to his wombat, with a drawing sent to Janey in 1869.*

133

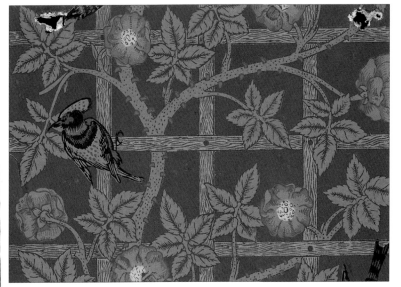

LEFT: Bird and Trellis *(1864),*
Morris's first wallpaper design, inspired
by the rose trellis in the garden at Red
House. Flowers, foliage and birds were
the staple motifs of his printed designs.
Often, as here, the birds were drawn by
Philip Webb.

ABOVE: *Tile designed by William*
Morris for William de Morgan. In
1880 Morris and de Morgan searched
vainly for factory premises they could
share, jokingly referring to the scheme
as 'the fictionary'.

down with scarlet fever that cost the life of her premature baby. Suddenly, the whole notion of a shared rose-garden in Kent seemed as fragile as the roses themselves, and was abandoned. 'For these two months, I have done no work, but lived most anxiously from day to day,' Ned told Allingham. 'The whole period has been so horrible and dismal that I try to forget it and will write no more about it.'

'As to our palace of Art, I confess your letter was a blow to me at first,' replied Morris to Ned, writing from his sickbed; 'though hardly an unexpected one – in short I cried.' However, he continued:

> now I am only 30 years old, I shan't always have the rheumatism, and we
> shall have a lot of jolly years of invention and lustre plates together I hope.

Sadly, before many more months had passed, the Morrises themselves had to leave Red House. The arduous daily journey, compounded by

RIGHT: *Architectural drawings by Philip Webb of the elevations for Red House, designed in 1859. With a housewife's practicality, Janey Morris complained that the coal cellars were too small.*

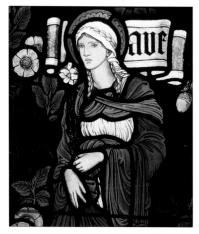

ABOVE: *Stained-glass image of the Virgin Mary designed by Burne-Jones for Morris & Co and first used in the church of St Martin's, Brampton, Cumbria.*

the shrinking income from investments, made return to central London imperative, and by 1866 the Morris Firm and family were re-established in Queen Square.

Here the business thrived. And with Rossetti in Chelsea, the Browns in Fitzroy Square and the Burne-Joneses re-settled in Kensington, social life also resumed. There were ambitious plans too for a sumptuous book of verse by Morris with Burne-Jones's woodcuts illustrating the tale of Cupid and Psyche. Allingham's diary conveys the atmosphere of these days:

TUESDAY JULY 31
Kensington Square ... Studio. N[ed] painting; imitates old
Connoisseur talking of 'Greek Art' etc. I in cab to D.G.R.'s. W.M.R.,
friendly – back from Naples, Vesuvius, Pompeii. Sandys, painter, large
heavy man with short yellowish hair parted in the middle. Tells me he

ABOVE: *Study for* The Wedding of Pysche *by Burne-Jones, who in 1865 collaborated with Morris on woodcut illustrations for a projected edition of Morris's* Earthly Paradise.

wants 'a dreary moor to paint – is there such a thing in the New Forest?' Enter Swinburne (his hair cut). Talk about ages ... Kensington Square about 3 ... Sleep not comfortably on my sofa.

WEDNESDAY AUGUST 1
Newspaper says cholera is increasing. I ask Ned to come down to Lymington, with wife and babes. Thinks of it. At dinner William Morris, pleasant, learned about wines and distilling. The Big Story Book, woodcut of Olympus by N. Jones. M[orris] and friends intend to engrave the woodblocks themselves – and M. will publish the book at his warehouse. I like Morris much. He is plain-spoken and emphatic, often boisterously, without an atom of irritating matter.

Ned and Georgie took up Allingham's offer to visit him in Hampshire, where on 30 August they were joined by Morris and Webb for a visit to Winchester. Allingham wrote in his diary:

Cathedral – west window, bits of old glass, choir, side aisles, Lady chapel, wall paintings, etc. Morris talked copiously and interestingly on all things, Webb now and again on technicalities (also interesting) Ned enjoyed the general charm and picturesqueness; I also, in my own way ...
... When we got to Stanwell House, Ned said 'I'm sorry, but I've been so lazy I've not done a single thing for the book' to which Morris gave a slight grunt. Then Ned produced eight or nine designs for the wood-blocks, whereupon Morris laughed right joyously and shook himself.

'I will give you a list of the company,' wrote Georgie's sister Agnes in a letter home after a party at Cheyne Walk:

Gabriel and William Rossetti, Mr, Mrs, Lucy and Katey Brown, a tall young woman, Janey and Morris, our three selves [herself, Georgie and Ned], Bell Scott, Munro the sculptor and his wife, F. G. Stephens, Mr and Mrs Arthur Hughes, Mr and Mrs Taylor, Legros [sculptor

ABOVE: *Janey Morris in 1865, one of a series of photographs taken at Cheyne Walk under Rossetti's supervision in which Janey, wearing a loose silk gown, adopted 'artistic' poses unlike those of studio portraiture. Some were later used by Rossetti as studies for paintings.*

Alphonse Legros] and his pretty English wife, and Webb and Swinburne. Mrs Brown, who was otherwise very nice, spilled a cup of coffee down Georgie's chinese blue silk dress like our bonnets, and for this we don't thank her as time can ne'er restore that dress ... Madox Brown was very jolly, but so grey that it made me feel sorry to see that his wife is one mass of fat ... I was a good part of the time with Janey, with whom I get on very well.

'My dear Mamma,' wrote Gabriel in the summer of 1866:

I am very anxious to paint your portrait. Do tell me what day next week you could come conveniently, sit to me, and dine. Maria and Christina might come too if they could, and enjoy the garden.

He was at the height of his powers and popularity, but found time to design the title page for his sister's second volume of poems, *The Prince's Progress*. This may obliquely have been directed against Gabriel, whom Christina feared was abandoning himself to sensuality in life and art.

> *Above his head a tangle glows*
> *Of wine-red roses, blushes, snows,*
> *Closed buds and buds that unclose*
> *Leaves and moss and prickles too;*
> *His hand shook as he plucked a rose*
> *And the rose dropped dew.*

Hunt, seeing Gabriel's new pictures, was disgusted by their sexiness. Nothing could be further from the idealism of the Brotherhood. And Ruskin agreed, writing frankly to Gabriel of the honeysuckle flowers in *Venus Verticordia*:

They are wonderful to me in their realism; awful – I can use no other word – in their coarseness, showing enormous power, showing certain

conditions of non-sentiment which underlie all you are doing now, and which make your work, compared to what it used to be – what Fanny's face is to Lizzie's ... In your interest only ... I tell you the people you associate with are ruining you.

In fact, Fanny's charms were fading. Gabriel was now becoming obsessed with Janey. Several people remarked on his behaviour one evening at the Browns', where he sat at Janey's feet offering her strawberries dipped in cream.

He persuaded her to sit, initially for a portrait and then for a sequence of similar paintings with romantic or symbolic themes. At first Morris could hardly object, and the portrait of his wife by his good friend and partner hung in pride of place at Queen Square, bearing its ambiguous inscription: 'Famous for her poet-husband and famous for her face, now may my picture add to her fame.'

'Beauty like hers is genius,' Gabriel proclaimed in verse, spinning sonnets on Janey's loveliness:

> O Lord of all compassionate control
> O Love! Let this my lady's picture glow
> Under my hand to praise her name and show
> Even of her inner self the perfect whole:
> That he who seeks her beauty's furthest goal,
> Beyond the light that the sweet glances throw
> And refluent wave of the sweet smile, may know
> The very sky and sea-line of her soul.
> Lo! it is done. Above the long lithe throat
> The mouth's mould testifies of her voice and kiss,
> The shadowed eyes remember and foresee.
> Her face is made her shrine. Let all men note
> That in all years (O Love, thy gift is this!)
> They that would look on her must come to me.

RIGHT: Venus Verticordia *(1864–8) by Rossetti. The goddess of love is shown holding the apple presented by Paris, together with Cupid's arrow. The choice of subject was probably influenced by Swinburne's hymns to Venus and contributed to Rossetti's reputation as a 'fleshly' artist.*

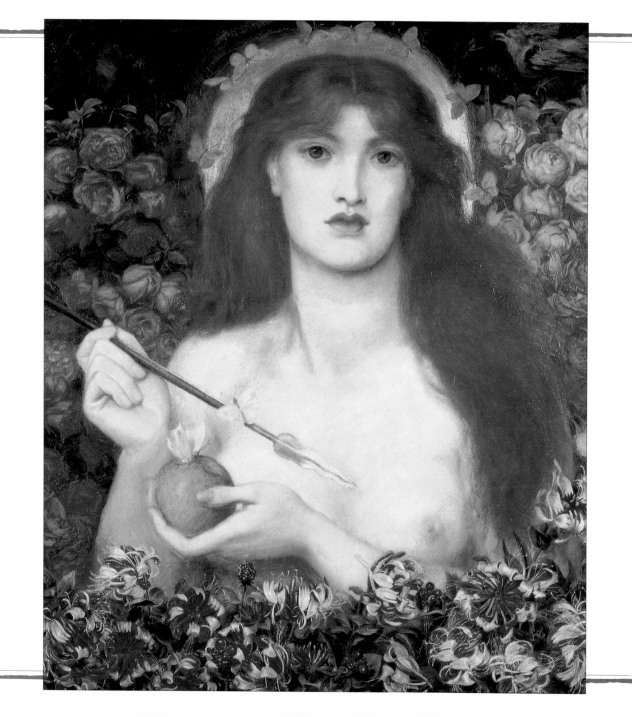

Janey was more than flattered. She had begun to suffer debilitating health that threatened her with invalidism. No treatment seemed to help, and in 1868 she was medically advised to take the waters at the spa of Bad Ems in Germany. Heroically, Morris accompanied her, though to him such a place was anathema. 'Imagine my Husband at a fashionable German watering-place!' wrote Janey to her American friend Mrs Eliot Norton.

Writing to Janey knowing that Morris would also read the letter, Gabriel was solicitous about her health:

> With what hope I await still better news and with what joy I shall receive it, pray believe me better than I can say. All that concerns you is the all absorbing question with me, as dear Top will not mind my telling you at this anxious time. The more he loves you, the more he knows that you are too lovely and noble not to be loved: and, dear Janey, there are too few things that seem worth expressing as life goes on, for one friend to deny another the poor expression of what is most at his heart ... I can never tell you how much I am with you at all times. Absence from your sight is what I have long been used to; and no absence can ever make me as far from you again as your presence did for years. For this long inconceivable change, you now know what my thanks must be.

It was hardly a letter calculated to allay Morris's anxieties; nor were the caricatures of himself and Jane at Ems ('The M's at Ems') that Gabriel sent with his letters.

This autumn, seven years after Lizzie's death, Gabriel determined to have her grave opened so that he might retrieve his manuscript from her coffin. 'My dear William,' he wrote, with extreme care:

> I wished last night to speak to you on a subject which however I find it necessary to put in writing ...

BELOW: *Binding designed by Morris for* The Earthly Paradise, *his collection of Classical and Nordic verse tales.*

BELOW: *'Topsy in a Toga': William Morris as Roman orator, in yet another affectionate caricature by Burne-Jones, poking fun at Morris's political campaigning.*

Various friends have long hinted from time to time at the possibility of recovering my lost MSS ... eventually I yielded, and the thing was done, after some obstacles ... All in the coffin was found quite perfect; but the book, though not in any way destroyed, is soaked through and through, and had to be still further saturated with disinfectant.

To Swinburne, he justified his action by an appeal to Lizzie's own love of poetry:

The truth is, that no one so much as herself would have approved of my doing this. Art was the only thing for which she felt very seriously. Had it been possible to her, I should have found the book on my pillow the night she was buried; and could she have opened the grave no other hand would have been needed.

This was probably true, but the macabre image of Lizzie opening her own coffin was also ominous. The bright world of Pre-Raphaelitism was soon to be made turbulent by betrayal and discord. Love and loyalty were tested as never before.

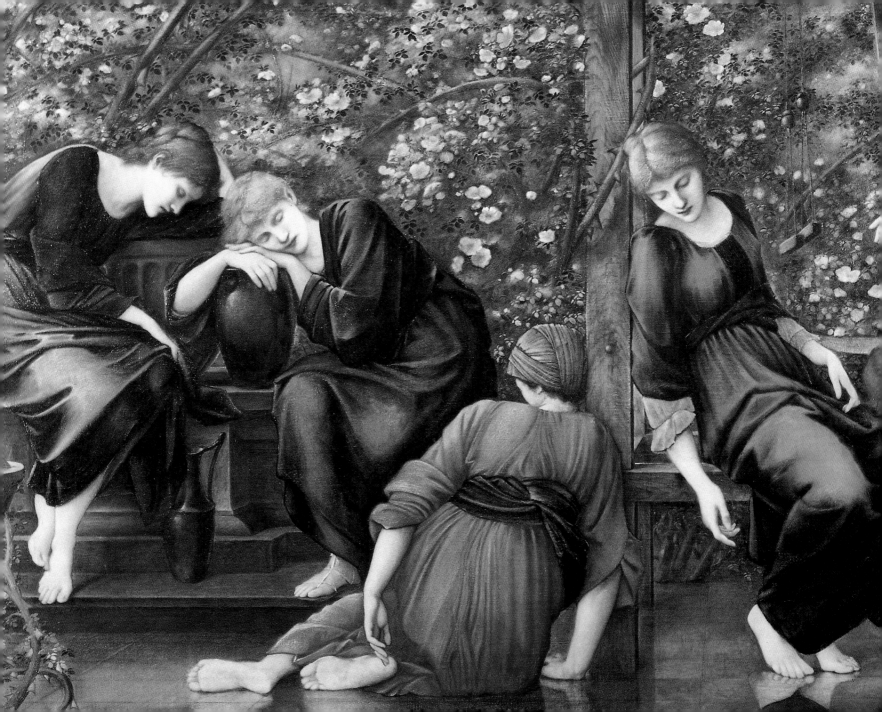

Chapter Eight

VENUS DISCORDIA

WHEN HIS MANUSCRIPT had been disinfected and deciphered (despite a large worm-hole through the centre), Rossetti put together a new collection of poems, published in the spring of 1870. These included a large number of love poems inspired by Janey, as she and close friends knew:

> *What other woman could be like you?*
> *Or how of you should love possess his fill?*

As yet, their love was not openly avowed, but Gabriel's letters left no doubt as to the strength of his feeling:

> To be with you and wait on you and read to you is absolutely the only happiness I can find or conceive in this world, dearest Janey, and when this cannot be, I can hardly exert myself to move hand or foot for anything ...
>
> I shall come up on Saturday evening and see how you are. But if I *should* be prevented then (or rather to speak plainly if I should resolve that it would be much pleasanter to come when no visitors were at your house) I will then come on Monday.

Morris, watching his wife's affection fade from her eyes, felt powerless. He poured out his distress in verses that were as melancholy as Gabriel's were joyful:

> *... time and again did seem*
> *As though a cold and hopeless tune be heard*
> *Sung by grey mouths amidst a dull-eyed dream.*
> *Time and again across his heart would stream*

LEFT: The Garden Court *(1894) by Burne-Jones. The story of the Sleeping Beauty, a Pre-Raphaelite favourite, fascinated Burne-Jones with its pictorial imagery of arrested time. This is the third in a sequence of scenes from the tale in which the Princess and her attendants are still unawakened.*

143

The pain of fierce desire whose aim was gone,
Of baffled yearning loveless and alone.

Unhappiness made him surly, too, even to Burne-Jones, his oldest friend:

My dearest Ned,

I am afraid I was crabby last night, but I didn't mean to be, so pray forgive me - we seem to quarrel in speech sometimes, and sometimes I think you find it hard to stand me, and no great wonder for I am like a hedgehog with nastiness.

But there was more than mere crabbiness. Morris was distressed on Georgie's behalf too, for Ned had added to the discord by also falling in love - with a white-skinned, flame-haired young woman who had left her husband, and presented an irresistible blend of beauty and sorrow.

Mary Zambaco, born Cassavetti, belonged to the cultured Anglo-Greek community in Britain and was one of a beautiful trio known collectively as 'the Three Graces', with whom half the artists in London were in love. Another was Marie Spartali, who became Brown's pupil (and a professional artist in her own right) as well as Gabriel's occasional model, and in later life Janey's close friend.

Ned promised to elope with Mary Zambaco, then withdrew. She proposed a suicide pact and then threatened to drown herself. As Rossetti wrote to Brown:

Private. Poor old Ned's affairs have come to a smash altogether, and he and Topsy, after the most dreadful to-do, started for Rome suddenly, leaving the Greek damsel beating up the quarters of all his friends for him and howling like Cassandra. Georgie has stayed behind. I hear today however that Top and Ned got no further than Dover, Ned being now so dreadfully ill that they will probably have to return to London. Of course the dodge will be not to let a single hint of their movements become known to anybody, or the Greek (whom I

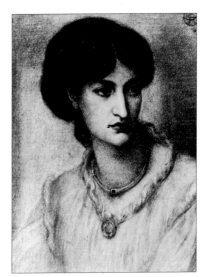

ABOVE: *Portrait of Aglaia Coronio (1870) by Rossetti. Clever and cultivated, Aglaia was daughter of Constantine Ionides, Pre-Raphaelite patron whose collection is now in the Victoria and Albert Museum. Her sister Elena married Whistler's brother.*

believe he is really bent on cutting) will catch him again. She provided herself with laudanum for two at least, and insisted on winding up matters in Lord Holland's Lane. Ned didn't see it, when she tried to drown herself in the water in front of Browning's house etc., – bobbies collaring Ned who was rolling with her on the stones to prevent it, and God knows what else.

Ned did not disengage easily, however. A few weeks later, having himself painted Mary many times – most notably as the sorceress Nimue, who enthralled Merlin, and as the nymph Phyllis, turned into an almond tree embracing her lover – he begged Gabriel to take her likeness too. Gabriel did his best, as he told Janey:

> I think I have made a good portrait of Mary Zambaco and Ned is greatly delighted with it. Indeed I enclose a note from that poor old dear which I have just got, which shows how nice he is. I like her very much and am sure that her love is all in all to her.

He liked Mary partly because she said Janey was beautiful, and also because:

> she is really extremely beautiful herself when one gets to study her face. I think she has got much more so within the last year with all her love and trouble.

Ned's note to Gabriel reveals his own distress at having failed Mary:

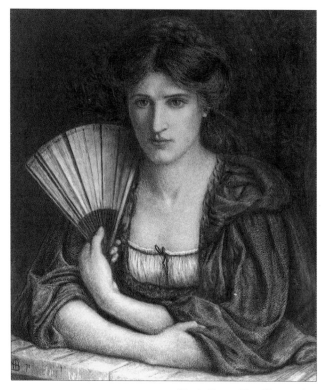

ABOVE: *Marie Spartali's self-portrait (1870) around the time of her marriage to American journalist W.J. Stillman. Marie's father hoped she would marry the widowed Rossetti, for whom she often sat. Trained by Madox Brown, Marie became an accomplished artist.*

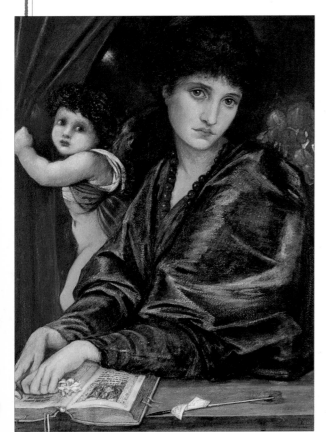

– all that portrait-making excited and exhilarated me and made me silly – I was so glad to have such a portrait, and for you to know her a little better – if ever so little – I thought you had little sympathy for me in the matter, before – and as I believed it to be all my future life this hurt me a bit. I can't say how the least kindness from any of you to her goes to my heart.

Chastened, Ned returned to the marital fold, while Morris stoically prepared to lose Janey to Gabriel. Divorce was virtually impossible, and always attended by scandal and social ostracism. The Victorian solution was thus the tacit re-arrangement of households, and intimacies such as that now offered to Topsy by Aglaia Coronio, Mary's cousin and the third of the Three Graces.

Aglaia interested herself in embroidery and literature. 'I will call on Tuesday and bring you your worsted,' wrote Morris:

> Ned says you want to know how to read Chaucer; I will bring a vol. in my pocket and with your leave will induct you into the mystery, wh. is not very deep after all: many thanks for your kind note – I have done my review, just this moment – ugh!

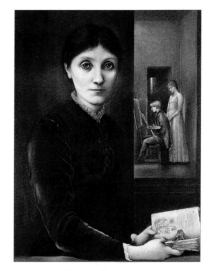

ABOVE: *Georgie Burne-Jones around 1875 with her children Philip and Margaret, by her husband. Sober and steadfast, Georgie remained his ideal of moral beauty. Their son Philip later became a painter too.*

ABOVE: *Contrasting images: here Burne-Jones's fanciful portrait of Mary Zambaco (1870) depicted with a Cupid symbolizing physical passion, and an arrow with the artist's name on it.*

His distaste came from the fact that this was a review of Rossetti's *Poems*. Even as he wrote, Janey was staying with Gabriel in the country.

A year later, in 1871, a longer-term solution was found, in the shape of an old manor house in Oxfordshire, where Jane and her daughters could spend the summer months, discreetly, with Rossetti. As Morris explained to Charles Faulkner, with what seems less than full candour:

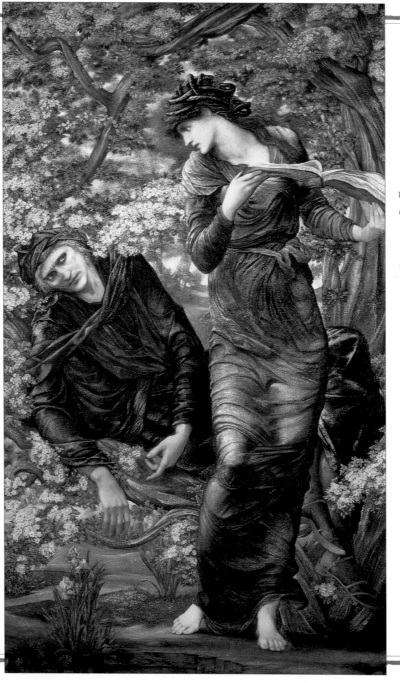

LEFT: The Beguiling of Merlin *(1874)*
by Burne-Jones. In the Arthurian tales,
the enchanter Merlin is himself cast
under a spell by Nimue, in an image of
the artist in thrall to female beauty that
seized the Pre-Raphaelite imagination.
Nimue here has Mary Zambaco's
distinctive profile, and her hair is
entangled with serpents.

I have been looking about for a house for the wife and kids, and whither do you guess my eye is turned now? Kelmscott, a little village about two miles above Radcott Bridge – a heaven on earth; an old stone Elizabethan house ... and such a garden! close down on the river, a boat house and all things handy. I am going there again on Saturday with Rossetti because he thinks of sharing it with us if the thing looks likely.

Having installed Jane in the Manor, Morris left for Iceland. He had acquired a passion for the Nordic Sagas, and also needed to put some emotional space between himself and events at home. Gabriel, as usual, laughed at his choices, until his own envy was aroused by hearing how Morris, author of *The Earthly Paradise*, was welcomed to Iceland as a famous bard.

Janey began decorating Kelmscott at once, writing to Philip Webb:

I am getting the fireplace set straight in the dining-room, the one with broken mantelshelf, perhaps you remember, and I think it would look well with tiles. Would you be so kind as to see about these at Queen Square for me? 6 dozen would be enough, 5 inch ones ... 2 rows on each side and single row along the top, the rest for the inside of the fireplace which will be an open one. Will they look best of various patterns or all alike? They must be blue. The mantelpiece is stone I find, so I am making the masons scrape off the former drab paint. The next thing to be thought of is a grate.

A week later she wrote again:

Many thanks for your taking so much trouble about things for me ... I will never pull down another fireplace as long as I live. I feel inclined now to leave it till Topsy comes back, for there are no competent workmen in the place; however the masonry is nearly finished and they cannot make any great mistake provided I stand by to show them which is the right way up of each tile.

ABOVE: *Kelmscott Manor, from the front garden, engraved by E.H. New for the frontispiece of Morris's utopian romance* News from Nowhere *(1890).*

ABOVE: *'Enter Morris, moored in a punt, And jacks and tenches exeunt': Rossetti's satire on Morris's fishing exploits at Kelmscott.*

'Let us hope Top is up to his navel in ice by this time and likes it!' wrote Gabriel to Webb, rather unkindly.

Although somewhat critical of the flat countryside, he too saw Kelmscott as an earthly paradise. He wrote to his mother that the house and its surroundings:

ABOVE: *Morris scaling icy peaks in Iceland, a more affectionate caricature by Burne-Jones, who did not share this passion for northerly climes.*

LEFT: *May Morris, aged ten, by Rossetti. Around this time, unbeknownst to May, Rossetti offered to adopt her. 'Why didn't you let him?' was her indignant response when told later.*

ABOVE: A Book of Verse, *written
and illuminated by Morris for
Georgie Burne-Jones, in token of their
friendship, 1870.*

are the loveliest 'haunt of ancient peace' that can well be imagined ... It has a quantity of farm-buildings of the thatched squatted order, which look settled down into a purring state of comfort, but seem (as Janey said the other day) as if, were you to stroke them, they would move ... She is benefitting wonderfully, and takes long walks as easily as I do. The children are dear little things – perfectly natural and intelligent and able to amuse themselves all day long ... I mean to make drawings of both.

Nine-year-old May found the summer idyllic. 'It must have been a hot pleasant summer that year my Father was away North,' she wrote later, 'and while he was riding among the black wastes and crossing the great rivers of that land of wonder we were basking by our gentle uneventful Thames'. But if quiet Kelmscott was entrancing to the two city-bred girls:

Poor mother manfully tried to make us do lessons ... [On] those glowing August mornings we sat in the pleasant cool of the Panelled Room trying to learn things about the Roman emperors, and outside the wide mullioned windows the blackbirds were chuckling and feasting among the gooseberries; golden stacks were growing roof-high in the yard outside, and the huge barn was alive with busy men and women. It was all too interesting.

May recalled one especially adventurous attraction of her childhood at the Oxfordshire manor house:

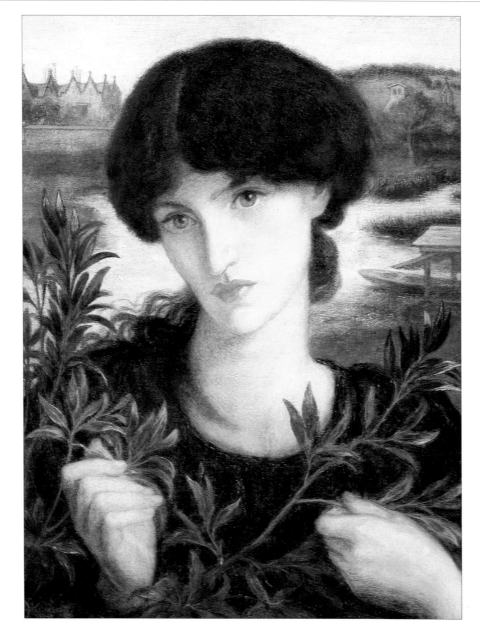

RIGHT: Water Willow *(1871)*
painted by Rossetti at
Kelmscott and showing the
Manor, church and boathouse
behind a wistful-looking Janey.
A copy of this picture now
hangs in Kelmscott Manor.

Among other things I took to roof-riding, the house with its many gables and the noble farm-buildings being particularly adapted to this pastime. One day, however, the feat did not quite come off – or rather I nearly did: for choosing to explore a specially inaccessible roof, having reached the ridge, there I sat astride and could not move.

Janey sent the gardener to borrow the village's longest ladders, and May was rescued from her perilous perch.

Gabriel drew and painted, or wrote poems to Janey:

Your hands lie open in the long fresh grass -
The finger-points look through like rosy blooms:
Your eyes smile peace. The pasture gleams and glooms
Neath billowing skies that scatter and amass.
All round our nest, far as the eye can pass
Are golden kingcup-fields with silver edge
Where the cow-parsley skirts the hawthorn-hedge.
'Tis visible silence, still as the hour-glass ...

Oh! clasp we to our hearts, for deathless dower,
This close-companioned inarticulate hour
When two-fold silence was the song of love.

The idyll did not last. The following year, as he and Janey were preparing to return to their love-nest, Gabriel suffered a severe nervous collapse, indistinguishable from paranoid schizophrenia. He never fully recovered, and though he continued to paint and to write, his last years were clouded and reclusive, as he shunned old friends. Janey stayed loyal for a while, until even she sadly acknowledged his permanently altered state. Gradually, she and Morris patched up their relationship. In 1874, Morris reorganized the Firm as Morris & Co., with himself in sole control. This led to a rift with

ABOVE: *Edward Burne-Jones aged forty-one, photographed at Naworth Castle, Cumbria.*

ABOVE: *Dante Gabriel Rossetti, aged forty-four. This sombre self-portrait seems to foreshadow the breakdown Rossetti suffered in 1872, curtailing his social life and casting an air of melancholy over his painting and poetry.*

Brown, and for some years the former friends were split into two camps, one centring on Morris and Burne-Jones and the other on Brown and William Rossetti, who married Lucy Brown.

In 1853 Gabriel had written, of the original P.R.B., 'Now the whole Round Table is dissolved.' Something similar had happened again, and although in later years the rifts were repaired, it is perhaps best to leave the Pre-Raphaelite story at this point, looking back on what came to seem a golden age of love, friendship and art.

Fifty years after the founding of the Brotherhood, Holman Hunt composed his memoirs. In his last paragraph he recalled the aspirations of those early days:

> The windows of the edifice [of art] should be opened to the purity of the azure sky, the prismatic sweetness of the distant hills, the gaiety of hue in the spreading landscape, and the infinite richness of vegetation. Nothing should henceforth be hidden from the enfranchised eye; we undertook to show that the rendering of new delights was not incompatible with the dignity of the highest art. The purpose of art is the love of guileless beauty.

If their lives were sometimes overshadowed, the art of the Pre-Raphaelites – painting, drawing, designs, decorated art – still shines with prismatic colour, infinite richness and mysterious beauty, speaking to us across the years.

BROWN, Ford Madox *(1821-93)*. Painter, born Calais. Settled in London after death of first wife in 1846 and, although not a member of the P.R.B., became closely associated with its aims and a leading figure in the movement, as well as a partner in Morris & Co. His daughters Lucy and Catherine also became artists. Brown's *Diary*, ed. Virginia Surtees (1981) is a valuable record of the Pre-Raphaelite circle in the 1850s. The best account of his life is in *Ford Madox Brown and the Pre-Raphaelite Circle* by Teresa Newman and Ray Watkinson (1991).

BURNE-JONES, Edward Coley *(1833-98)*. Painter, born Birmingham; at Oxford University formed lifelong friendship with William Morris; founder and contributor to The Oxford and Cambridge Magazine. Moved to London 1856 as follower and friend of D. G. Rossetti. Partner in Morris & Co and chief designer of stained glass. Married Georgiana Macdonald in 1860; became leading exponent of 'second-wave' Pre-Raphaelite movement in 1870s and '80s. His life is chronicled in *Memorials of Edward Burne-Jones*, by his wife (2 vols, 1904, re-issued 1913), and in Penelope Fitzgerald's biography (1975). The fullest account of his art, is *Burne-Jones* by Martin Harrison and Bill Waters (revised edition 1989).

BURNE-JONES, Georgiana *(1840-1920)*. Born Georgiana Macdonald, daughter of a Methodist minister; trained in illustration and wood-engraving before marriage to Burne-Jones in 1860; close friend of the Browns and especially of William Morris from 1860s onwards; author of *Memorials* of Edward Burne-Jones (1904) and moving spirit behind first biography of Morris (1899). Her own life is chronicled in Ina Taylor, *Victorian Sisters* (1987), as well as in Jan Marsh, *Pre-Raphaelite Sisterhood* (1985).

COLLINS, Charles Allston *(1828-73)*. Painter, born London, son of painter William Collins and brother of novelist Wilkie Collins. Studied at Royal Academy Schools and became close friend of John Millais. Later in the decade abandoned painting for writing.

COLLINSON, James *(1825-81)*. Painter, born Nottinghamshire and trained at Royal Academy Schools, where he met D. G. Rossetti, William Holman Hunt and others. Founder member of the P.R.B. and contributor to *The Germ*; engaged to Christina Rossetti 1848-50, when he resigned from P.R.B. owing to religious scruples.

HUGHES, Arthur *(1832-1915)*. Painter, born London and trained at Royal Academy Schools, where inspired to emulate P.R.B. after reading *The Germ*. Became friendly with John Millais and D. G. Rossetti, and invited to participate in Oxford Union mural scheme.

HUNT, William Holman *(1827-1910)*. Painter, born London and trained at Royal Academy Schools, where met John Millais. Inspired by John Ruskin's *Modern Painters* and *Life and Letters of John Keats*. His *Eve of St Agnes* (RA, 1848) led to friendship with D. G. Rossetti and formation of P.R.B. Intent on producing a major religious painting, Hunt travelled to the Middle East 1854-6 in search of authentic settings. Success of *Finding of the Saviour in the Temple* (1860) established him as a leading artist, adhering to original principles of P.R.B. His memoirs, *Pre-Raphaelitism and the Pre-Raphaelite Brotherhood* (2 vols, 1905, revised 1913), form one of the major sources for the movement. Diana Holman-Hunt, *My Grandfather, His Wive and Loves* (1969) chronicles his personal relations with model Annie Miller and consecutive wives, Fanny Waugh and her sister, Edith Waugh.

MILLAIS, John Everett *(1829-96)*. Painter, born Southampton to family from Channel Islands; trained at Royal Academy Schools; met Holman Hunt and in 1848 D. G. Rossetti; P.R.B. launched in his studio, and his works were those by which the movement first became known: Isabella (1849), *Christ in the Carpenter's Shop* (1850), *Ophelia* (1852), *The Order of Release* (1853), *The Blind Girl* (1856), *Autumn Leaves* (1856). In 1855 married Effie Gray, former wife of John Ruskin. By late 1860s no longer working in Pre-Raphaelite style nor in contact with former colleagues, but hugely successful as a painter of historical genre scenes. President of the Royal Academy 1896. The Life and Letters of John Everett Millais, edited by his son (2 vols, 1899), is a major source for early days of P.R.B.

MORRIS, Jane *(1840-1914)*. Born Jane Burden, in Oxford; 'discovered' by D. G. Rossetti during the Oxford Union mural scheme; married William Morris in 1859. Expert needlewoman and supervisor for Morris & Co, and amateur designer and bookbinder. Love affair with D. G. Rossetti 1868-75. At the end of her life purchased Kelmscott Manor, thus enabling its preservation for posterity. Her correspondence from Rossetti, ed. John Bryson, was published in 1976.

MORRIS, William *(1834-96)*. Poet, designer, Socialist, born Essex; at Oxford University formed lifelong friendship with Edward Burne-Jones; founder and contributor to The Oxford and Cambridge Magazine, also participant in Oxford Union mural scheme. Studied architecture and then painting, before becoming main designer of wallpaper and fabrics as well as managing director of Morris & Co. First book of poems, *The Defence of Guenevere* (1858), is the most Pre-Raphaelite. First home Red House; later took Kelmscott Manor and Kelmscott House, Hammersmith, where became leader of Socialist movement in 1880s; other achievements include the founding of the Society for the Protection of Ancient Buildings, inspiration for Arts and Crafts movement 1880s-1900, and founding of the Kelmscott

Press 1890. His *Collected Works* (24 vols, 1910-15) were edited by his daughter May Morris; his *Collected Letters* (5 vols, 1984-96) by Norman Kelvin; the latest biography is by Fiona MacCarthy (1994).

ROSSETTI, Christina Georgina *(1830-94)*. Poet, born London to family of Italian origin; younger sister of D. G. and W. M. Rossetti; contributor to *The Germ*; sitter for Gabriel's *The Girlhood of Mary Virgin* (1849) and *Ecce Ancilla Domini!* (1850). Author of *Goblin Market* (1862), *The Prince's Progress* (1866), *Sing-Song* (1872) and many devotional works. Her *Collected Poems* (3 vols, 1979-90) are edited by R. W. Crump and her *Collected Letters* (3 vols, 1996 onwards) by Antony H. Harrison.

ROSSETTI, Dante Gabriel *(1828-82)*. Painter and poet, born London; studied at Royal Academy Schools, where met William Holman Hunt and John Millais; moving spirit behind foundation of P.R.B. and launch of *The Germ*, and driving force in both phases of Pre-Raphaelite movement. Introduced to John Ruskin 1854; married Elizabeth Siddal in 1860. Leader of Oxford Union mural scheme; partner in Morris & Co 1861-74. Books include *The Early Italian Poets* (translations, 1861); *Poems* (1870); *Ballads and Sonnets* (1881). Illustrated his sister's *Goblin Market* and *The Prince's Progress*. From 1862 lived at Tudor House, Chelsea, and 1871-4 shared tenancy of Kelmscott Manor with William and Jane Morris, while in love with Jane. Suffered major mental collapse in 1872. *The Letters of Dante Gabriel Rossetti* (4 vols, 1865), ed. Oswald Doughty and J. R. Wahl, are due to be superseded by a forthcoming comprehensive edition, ed. W. E. Fredeman. The *catalogue raisonné* of his works, ed. Virginia Surtees (2 vols, 1971), is augmented by the CD-ROM version, from the University of Virginia, ed. Jerome McGann; see also the lavishly illustrated *Dante Gabriel Rossetti* by Alicia C. Faxon (1989). As yet, there is no biography to supersede that of Oswald Doughty, *A Victorian Romantic* (1949).

ROSSETTI, William Michael *(1829-1919)*. Art critic and historian of Pre-Raphaelite movement, born London, younger brother of Dante Gabriel Rossetti; government employee 1845-94. Founder member of P.R.B. and keeper of its Journal; editor and contributor to *The Germ*. Art critic for many years and author of *Fine Art: Chiefly Contemporary* (1867). Married Lucy Madox Brown in 1874. Author and editor of numerous Pre-Raphaelite and Rossetti volumes, including *Family Letters of Dante Gabriel Rossetti, with a Memoir* (2 vols, 1895), *Pre-Raphaelite Diaries and Letters* (1900), *Poetical Works of Christina Rossetti* (1904) and *Some Reminiscences* (2 vols, 1906). His own *Selected Letters* are edited by Roger Peattie (1990).

RUSKIN, John *(1819-1900)*. Critic, patron and social philosopher, born London, educated at home and Oxford University. Champion of J. M. W. Turner in *Modern Painters* (vol. I, 1843), of Gothic architecture in *The Stones of Venice* (1853) and of the Pre-Raphaelites, to whose defence he came in 1851. Patron of Millais until his marriage to Ruskin's former wife; also patron to William Holman Hunt, D. G. Rossetti and Elizabeth Siddal. From 1860 concentrated on social criticism. Legal dispute with J. M. Whistler 1874, followed by mental breakdown, social isolation and virtual silence. His *Collected Works* (34 vols, 1900-12) were edited by J. A. Cook and A. Wedderburn.

SCOTT, William Bell *(1811-90)*. Painter, born Edinburgh, trained as engraver. Moved to London 1837, then to Newcastle as principal of School of Design 1843-64. Met D. G. Rossetti 1847 and contributed to *The Germ*. His *Poems* (dedicated to D. G. Rossetti, William Morris and A. C. Swinburn) were published in 1875, and *Autobiographical Notes* (2 vols, ed. W. Minto) posthumously in 1892.

SEDDON, Thomas *(1821-56)*. Painter, born London, brother of architect J. P. Seddon. Travelled in Middle East 1854 with William Holman Hunt, painting landscapes; returned to Egypt 1856 and died there. His letters home, edited by his widow, were published in 1860.

SIDDAL, Elizabeth Eleanor *(1829-62)*. Artist and model, born London; first met P.R.B. around 1850, when modelled for major paintings, including William Holman Hunt's *Proteus Rescuing Sylvia*, and John Millais's *Ophelia*. In 1852 became pupil of, and romantically attached to, D. G. Rossetti and in 1855 received patronage from Ruskin. Contributor to 1857 Pre-Raphaelite show at Russell Place. Married D. G. Rossetti 1860, stillborn daughter 1861, died of opium overdose 1862. Her biographical history is traced in Jan Marsh, *The Legend of Elizabeth Siddal* (1989).

STEPHENS, Frederic George *(1828-1907)*. Painter and critic, born London, trained Royal Academy Schools. Member of P.R.B. and contributor to *The Germ*. Gave up painting in favour of art journalism and teaching; wrote on William Holman Hunt in 1860 and D. G. Rossetti in 1894.

WEBB, Philip *(1831-1915)*. Architect and designer, born Oxford, where trained with G. E. Street, in whose office he met William Morris, for whom he designed Red House (1859-60). Partner in Morris & Co., designer of furniture, metalware, stained glass. Close associate of Morris in Society for the Protection of Ancient Buildings and member of Socialist League. His buildings include Standen, East Grinstead (National Trust); Glebe Place, Chelsea, for painter G. P. Boyce; and a pair of cottages at Kelmscott village, erected by Jane Morris in memory of her husband.

WOOLNER, Thomas *(1825-92)*. Sculptor and member of P.R.B., who trained at Royal Academy Schools. Contributor to *The Germ*. Sculpture commissions unforthcoming in Britain, he followed the 'gold rush' to Australia in 1852. (His departure inspired Madox Brown's emigration picture *The Last of England*.) Returned to Britain in 1854 and established a career in portrait sculpture. Married Alice Waugh in 1864. Elected to Royal Academy 1875 and thereafter pursued career producing public monuments.

IN THE FOOTSTEPS OF THE PRE-RAPHAELITES

A LTHOUGH SO MUCH has changed since the Victorian era, many of the places associated with the Pre-Raphaelites may still be visited, and their works seen on display.

In Oxford, where Rossetti and his friends spent the summer of 1857, the Ashmolean Museum in Beaumont St. has a collection of Pre-Raphaelite paintings, drawings and designs, together with a wardrobe painted by Burne-Jones for William Morris. Holman Hunt's Light of the World is in Keble College chapel; both Christ Church and Manchester College have important Pre-Raphaelite stained glass; in the Oxford Union Library (formerly debating chamber) in Frewin Court, OX1 3JB, are the remains of the Arthurian murals painted by Rossetti and friends, open to the public during university vacations; details from 01865 241353.

Some miles westward, towards Lechlade, stands Kelmscott Manor, originally shared by Morris and Rossetti, bequeathed by May Morris in 1938 and now preserved by the Society of Antiquaries; open to the public in summer; details from the Custodians, Kelmscott Manor, Kelmscott, GL7 3HJ.

In London, the basement and coach house (formerly Socialist meeting room) at Kelmscott House, 26 Upper Mall, Hammersmith, London W6 9TA, is home to the William Morris Society; opening hours and membership details from 0181 741 3735. The Tate Gallery holds a major collection of Pre-Raphaelite works. Decorative work by Burne-Jones, Morris & Co, May Morris and many others, together with paintings by Rossetti, are in the Victoria & Albert Museum.

On the north-eastern outskirts of London, the William Morris Gallery, Water House, Forest Road, London E17 4PP, formerly the home of Morris's mother, is now a small but exceptional museum devoted to his life and work; for opening hours telephone 0181 527 3782. To the south-east of London is Red House, Red House Lane, Bexleyheath, Kent, built for Morris and still retaining original features; open to visitors once a month by written arrangement (enclose s.a.e.).

Birmingham City Museum and Art Gallery, Chamberlain Square, has a large collection of important Pre-Raphaelite paintings; the cathedral church nearby has windows by Burne-Jones and is home to the Pre-Raphaelite Society; write to Cathedral Church of St Philip, Colmore Row, Birmingham B3 2QB. Near Wolverhampton, Wightwick Manor, although without direct connections to the artists, is decorated in Pre-Raphaelite style: owned by the National Trust and open all the year.

Manchester City Art Gallery, in Mosley St., has a major collection of Pre-Raphaelite art, set in Victorian rooms. Manchester Town Hall, close by, has murals by Ford Madox Brown. Other important paintings are in the Walker Art Gallery, William Brown St., Liverpool, and the Lady Lever Art Gallery, Port Sunlight.

In the United States, Pre-Raphaelite works can be seen at the Delaware Art Museum, Wilmington, and the Fogg Art Museum, Harvard University, Massachusetts. The National Gallery of Canada, Ottawa has a small collection of Pre-Raphaelite works, while decorative art is to be found in the Royal Ontario Museum, Toronto, and Kelmscott Press books in the Rare Book Library, University of Toronto. In Australia, visit the National Gallery of Victoria in Melbourne. In Japan, there are works by Rossetti and Burne-Jones in the Koriyama City Museum of Art, Koriyama-shi, Fukushima-ken.

INDEX

INDEX

ACKNOWLEDGEMENTS

Illustrations appear by kind permission of the following:
Ashmolean Museum, Oxford 26, 34, 40, 54 (right), 68 (left), 90; Birmingham Museum & Art Gallery 12 (right), 15, 20, 33 (both), 41, 68 (right), 70 (right), 71, 73, 80, 39, 58 (right), 70 (left), 95 photos Bridgeman Art Library; 37, 101, 108 (left),128, 140 (right) photos Courtauld Institute; Bolton Museum & Art Gallery 54 (left); Boston Museum of Fine Arts, gift of James Lawrence 119; Bridgeman Art Library 50; Bristol City Art Gallery 142 photo Bridgeman Art Library; British Museum, London 60, 75, 76/77, 103, 112, 113 (right), 122, 125, 133 (right), 141, 148 (right); Carlisle Museum & Art Gallery 116; Christie's Images 12 (left), 51, 61, 65, 67, 89 (left), 96, 114, 117, 121, 124, 130, 135 (right), 136, 149 (right); Clement Sels Museum, Neuss 146 (left); Courtauld Institute, Witt Library 45, 56, 69; Delaware Art Museum, Samuel and Mary Bancroft Memorial 46, 74 photo Bridgeman Art Library 140 (left), 145, 151; Edifice 134 (left); Fine Art Society, London 82 photo Bridgeman Art Library 100 (left); Fitzwilliam Museum, Cambridge 13 (left), 31 photo National Portrait Gallery 64 (left) and 72 photos University of East Anglia 76, 102, 115, 120 photos Bridgeman Art Library; Greater London Record Office 78; Huntingdon Library, California 29; Lady Lever Art Gallery, Port Sunlight 2, 99 photos National Museums and Galleries on Merseyside, 147 photo Bridgeman Art Library; Laing Art Gallery, Newcastle upon Tyne, front cover photo Bridgeman Art Library; Jeremy Maas Ltd, London 28, 88 (left); Manchester City Art Gallery 42, 59 , 66, 79 photos Bridgeman Art Library; Peter Nahum Ltd, London 149 (left); National Gallery of Ireland, Dublin 113 (left); National Portrait Gallery, London 17 (left), 48, 64 (right), 85, 133 (left); National Portrait Gallery Archive 80; National Trust, Wightwick Manor 17 (right), Batemans 127; Pierpont Morgan Library, New York 53; Private Collections 13 (right), 19; 20, 32 (right), 146 (right); 35, 43 photos Bridgeman Art Library 20, 32, 37 (top right and bottom right) 108 (right) photos Courtauld Institute; 55 photo Tate Gallery 58 (left); Russell-Cotes Art Gallery, Bournemouth 139 photo Bridgeman Art Library; Sanderson, 112-120 Brompton Rd, London SW3 1JJ, endpapers; Sotheby & Co. 32 (left), 86, 89 (right), 100 (right); Southampton City Art Gallery 91; Tate Gallery, London 6, 8, 10 , 14, 18, 19, 25, 30, 36, 37 (bottom right), 62, 83, 98, 106, 107, 111,123; Uffizi, Florence 87 photo Scala; Victoria & Albert Museum, London 16, 57, 126, 131, 134 (right), 136/137,144, 150; Walker Art Gallery, Liverpool 24 photo Bridgeman Art Library; Yale University, Beinecke Rare Book Library 52 (right).

Illustrations from books:
Georgiana Burne-Jones, *Memorials of E. Burne-Jones,* London (1904) 109, 110, 129, 132, 152, 153.
The Germ, reprinted Portland, Maine (1898) 21.
William Holman-Hunt, *Pre-Raphaelitism and the Pre-Raphaelite Brotherhood,* London (1905) 14/15, 88 (right), 92, 93, 97.
John G. Millais, *The Life and Letters of Sir John Everett Millais,* London (1899) 44, 49 (right), 52.
Alfred Tennyson, *Poems*, London (1857) illustrated edition published by Edward Moxon 9, 81, 84.